CROSSPOOL

THROUGH TIME

Judith Hanson

AMBERLEY PUBLISHING

Dedicated to the people of Crosspool, past and present, wherever you may be.

First published 2010

Amberley Publishing Plc
Cirencester Road, Chalford,
Stroud, Gloucestershire, GL6 8PE

www.amberley-books.com

Copyright © Judith Hanson, 2010

The right of Judith Hanson to be identified as the
Author of this work has been asserted in accordance
with the Copyrights, Designs and Patents Act 1988.

ISBN 978 1 84868 681 6

British Library Cataloguing in Publication Data.
A catalogue record for this book is available from
the British Library.

Typeset in 9.5pt on 12pt Celeste.
Typesetting by Amberley Publishing.
Printed in the UK.

Introduction

Where is Crosspool? No one is ever sure where it starts and finishes. In the seventeenth, eighteenth and much of the nineteenth centuries the district was a sparsely populated backwater, mostly agricultural but also with a tiny cottage industry.

In 1821 Crosspool district consisted of four small hamlets of stone -roofed cottages, Tapton, Lydgate, Crosspool and Stephen Hill. With the introduction in that year of the turnpike road from Sheffield to Manchester, things began to change. A local trade in building materials developed and a brickworks was opened on Benty Lane. In 1830 the schoolhouse was built, (also on Benty Lane) under the auspices of 'The National Society for Promoting the Education of the Poor in the Principles of the Established Church'.

During the eighteenth century there were pools at Crosspool, Stephen Hill, High Green (near The Plough) and the corner of Marsh Lane and Lydgate Lane. The ones in more recent memory were the result of the excavation of clay for building.

With the opening of the Manchester Road more facilities were required and the first specially built inn, The Kings Head, was erected in 1829. One of the earliest developments was around Vernon Terrace and Tapton Bank in the 1880s. Building continued on Benty Lane, and Manchester, Selborne, Cairns, and Sandygate Roads.

In the first decade of the twentieth century traffic was still light and consisted mainly of farm vehicles, coal carts on their way to Lodge Moor Hospital and stone carts from local quarries. In an article in the *Daily Independent* of 1938, Crosspool is described as 'Perched high above the city, amid beautiful surroundings, Crosspool is more like a health resort than a thriving suburb. Actually it is both'.

Building really took off in the 1920s and '30s when the present road layout was developed and the hundreds of semi detached houses were built. Put on hold during the war years, building began again in post

war years so much so, that land on Coldwell lane was bought by the residents to ensure that there would be some open play space for the children of the area.

In 1966 an article in the Sheffield Spectator says 'Crosspool is now such an integral part of the almost completely built up area of Sandygate, Tapton Hill, Lydgate, Clough Fields that it is difficult to visualise its earlier position of isolation'.

The same magazine, but in 1973 states that ' the factors which once made Crosspool undesirable as a residential area, are now the very factors which make it desirable. The situation on the very edge of the moors is an advantage now. The fresh bracing air is like a tonic, a pleasant change for workers returning home from parts of smoke crowned Sheffield'.

In this book I have attempted to reflect the development of the area. Street furniture, traffic and growth of trees have sometimes made it impossible to take photos from the same angle as the old photographs. Most of the new photos have been taken in winter in order to get the appropriate views.

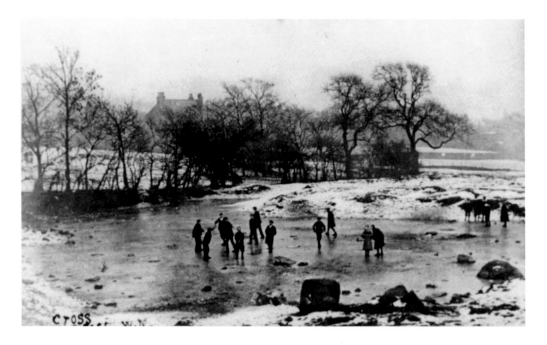

The Pools
Children skated on one of the pools formed by the excavation of clay used for making bricks. The pool was to be found off Selborne Road. Now filled in, water can still cause problems on the neighbouring playing fields.

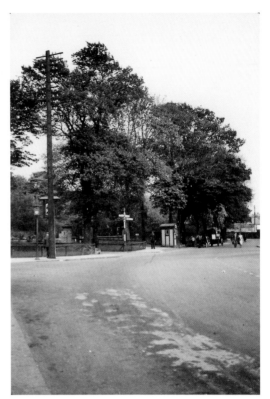

Manchester Road

Built in 1820 Manchester Road was a new road replacing in importance Lydgate Lane, and especially the route which ran along Shore Lane, Tapton Hill Road and Benty Lane. The sign for Crosspool Tavern can be seen behind the telegraph pole in the photo of 1933.

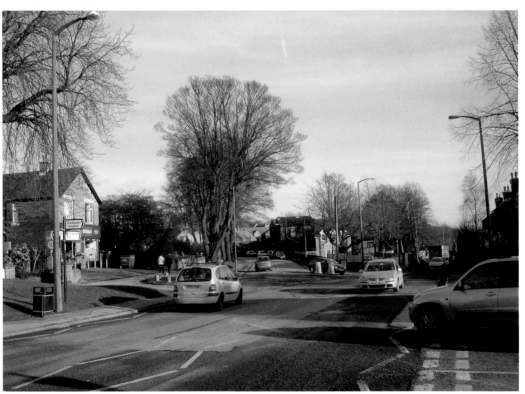

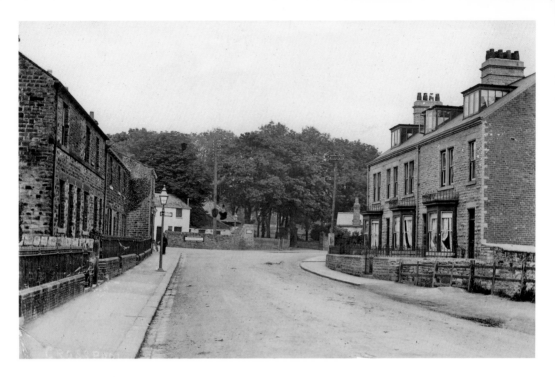

Sandygate Road
Looking north along Sandygate Road to the gates of Lydgate Hall at the junction of Manchester Road and Lydgate Lane. By the early 1950s the front gardens on both sides of the road had been removed and the houses converted into shops. Crosspool Tavern can be seen in the background.

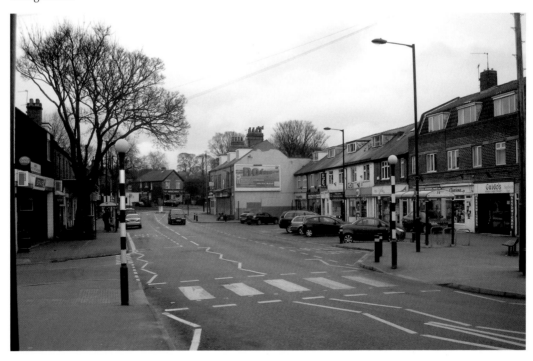

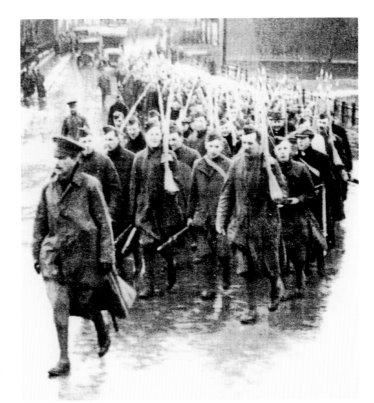

The March to Redmires Sheffield Battalion of the Yorks and Lancs regiment are on their way to their training camp at Redmires in 1914. Although seeming quite busy, the area is still residential rather than commercial, but the building layout remains the same as today.

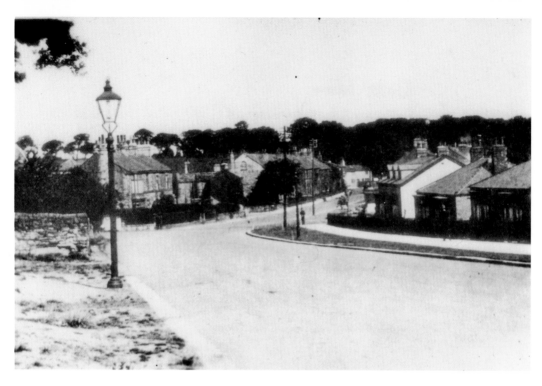

Watt Lane

An early photograph of Sandygate Road from Watt Lane. Again the shops have not arrived but the bungalows on the right look quite modern. In the 1800s Watt Lane was known as Crosspool Road.

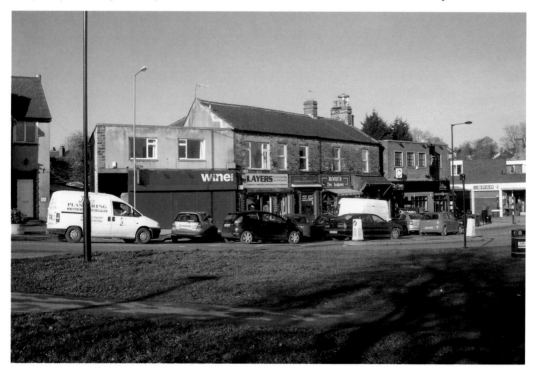

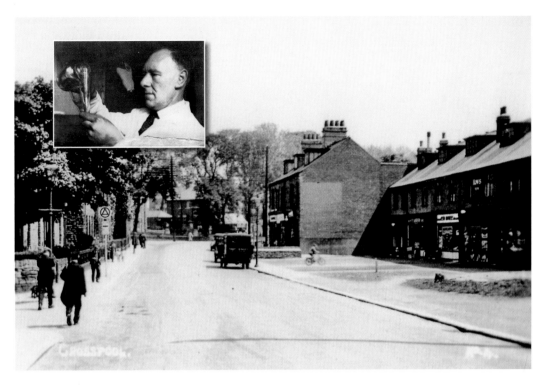

The Shopping Centre

In the 1920s many of the houses on Sandygate Road had been converted into shops and new ones built with living accommodation above. Mr R. Coppock was manager and pharmacist at Preston chemist's shop from 1939 to 1973. Since then the shop has been Vantage chemists and is now Crosspool Pharmacy.

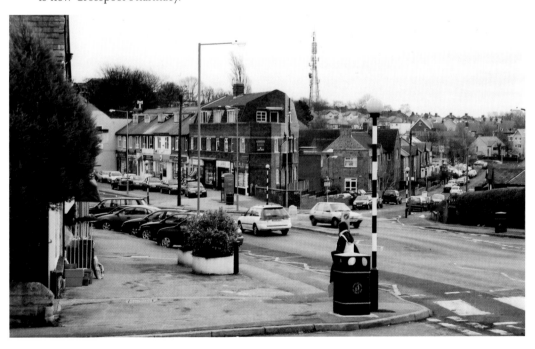

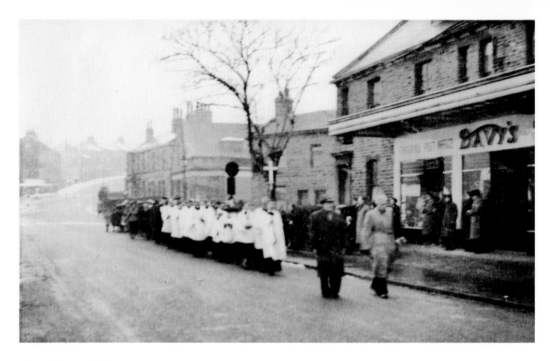

The Old Post Office

For many years the post office was part of Ranson's shop at the corner of Manchester Road and Sandygate Road. It moved to 20 Sandygate Road in the 1950s, where it remained as an independent and popular post office and stationers until 2004 when it moved into the Spar Convenience store at the corner of Benty Lane. 20 Sandygate Road then became a short lived turf accountants and is now a craft shop. The canopy over the shops remains a good place to shelter.

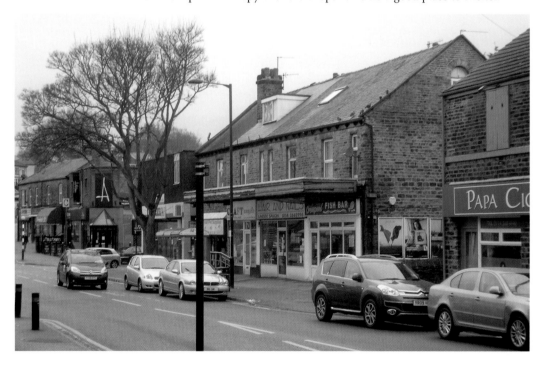

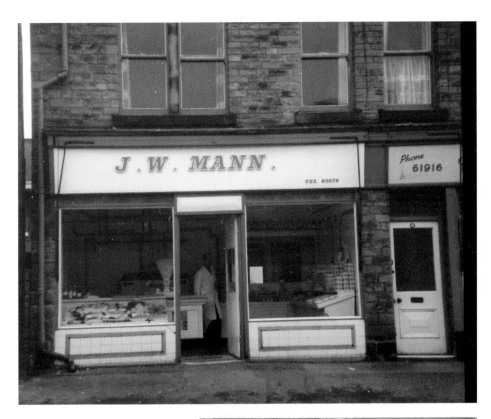

Mann's Shop

John and Hazel Mann were proprietors of the shop at 9 Sandygate Road from 1960 until 1983. Before they took it on it was a fish shop owned by Frank Darwin. The Manns also sold fish and added fruit and vegetables to their range. In 1983 the Manns retired, the shop became a fish and chip shop and is now a Chinese take away.

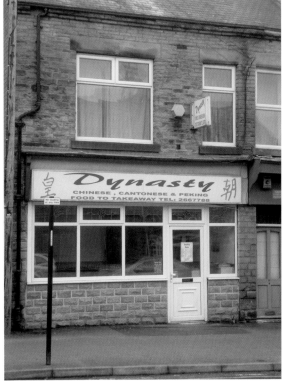

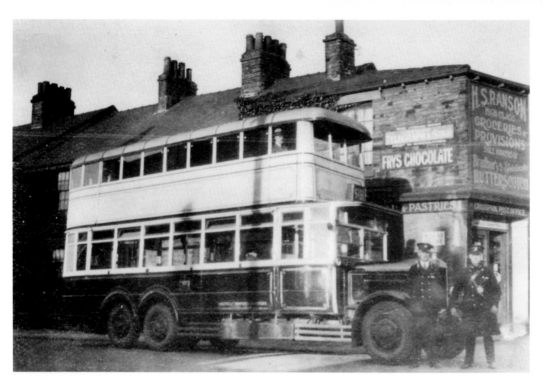

Ranson's Shop

Ranson's shop was a general store and post office. A six wheeled bus stands at the bus stop in 1927. The shop is now a hairdresser's.

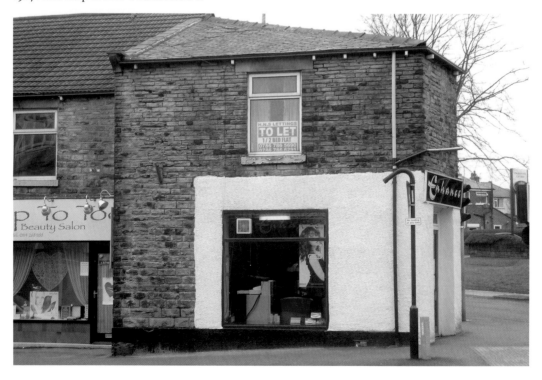

The Hollies

The Hollies was a row of houses which stood on Sandygate Road before being transformed into shops. On the right hand side of the old photo the Sheffield and Ecclesall Co-op can be seen, the shop now being two popular restaurants.

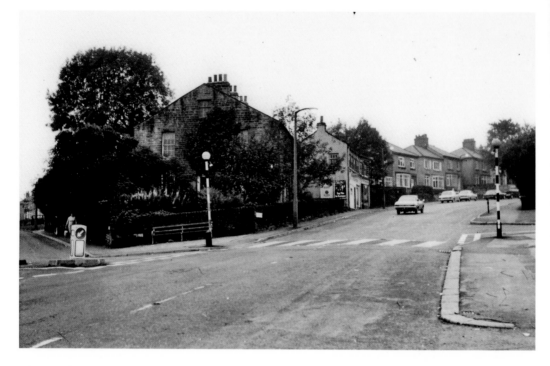

Ringstead Crescent

In the photograph from 1960 Ringstead Crescent can be seen to the right and Watt Lane to the left. At the centre of the photograph are shops — at various times a cobbler's, baker's and interior design shop — these now being private houses. The junction with Watt Lane has been changed to improve road safety.

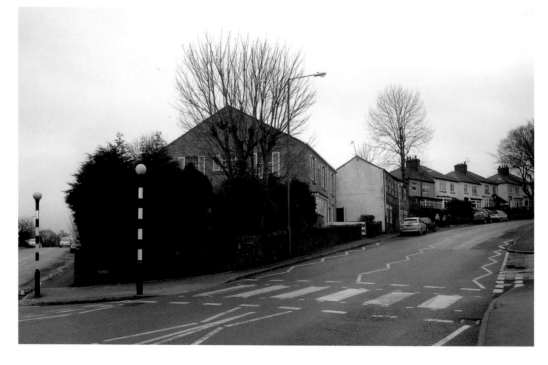

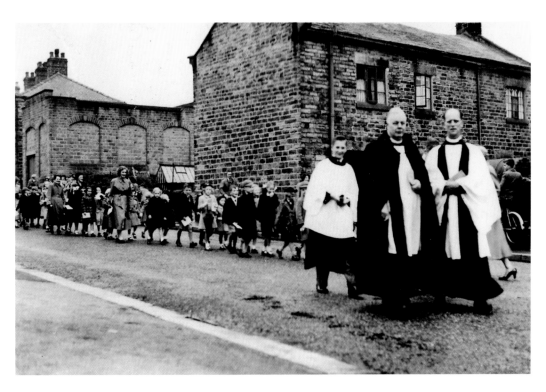

Cottages, Benty Lane

Benty Lane was quite an important road before the construction of Manchester Road. The cottages in the foreground of the old photograph have been demolished but the ones in the background remain.

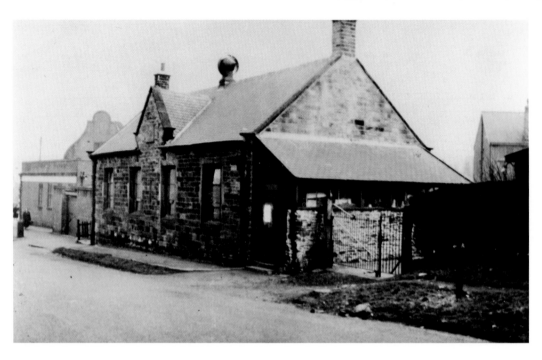

The Old School

Crosspool Church school was built in the 1830s. In 1907 the children were transferred to the newly built Lydgate Lane School. The old school, since then, has been used as a church for the Anglican community, a library, as St. Francis Roman Catholic Church and since 1989 as The Old School Nursery.

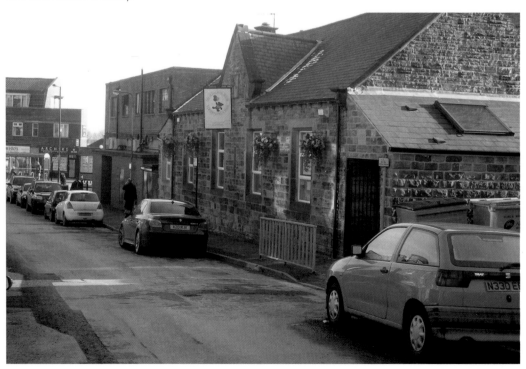

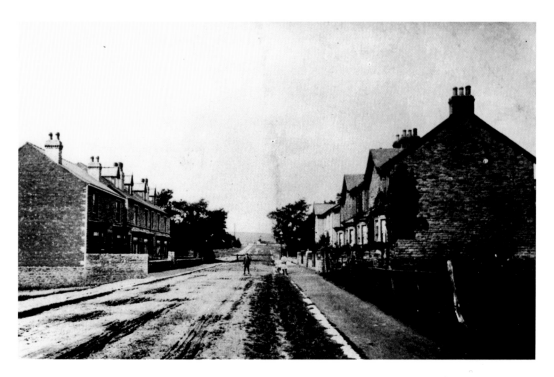

Selborne Road

The first houses were built on Selborne Road at the end of the nineteenth century. The road was unsurfaced and could be closed off by the erection of horizontal poles at either end. Cairn Home, originally for blind men was opened in 1935. It now accommodates over twenty elderly people.

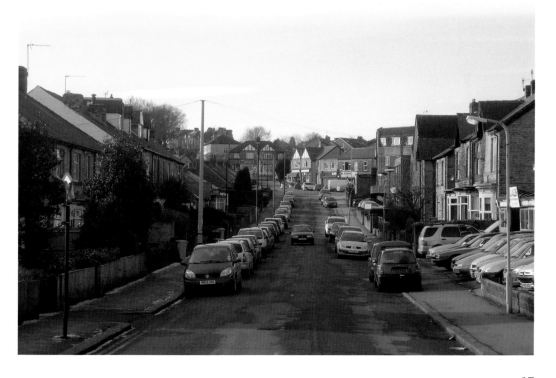

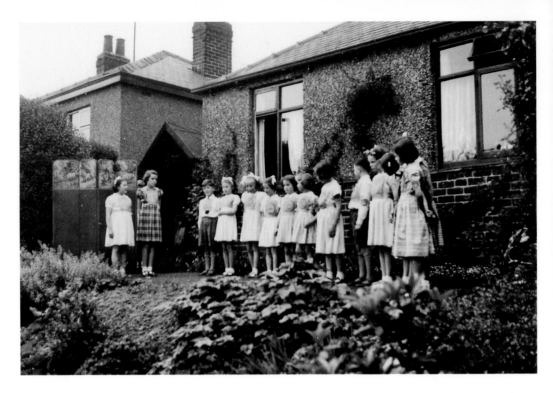

Party Time!
Miss Warner, a member of St Columba's Church lived at 43 Selborne Road. She held annual garden parties for the members of the church and the children entertained. Nowadays, as part of the Crosspool open gardens in July, Cairn Home also holds a garden party on Selborne Road.

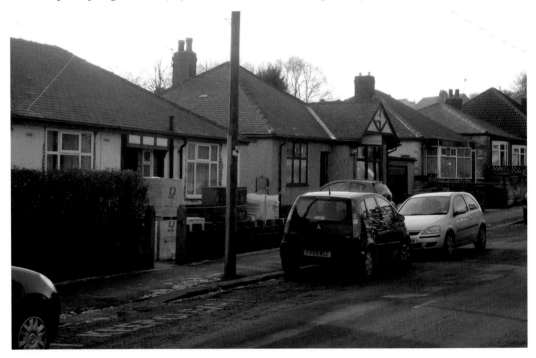

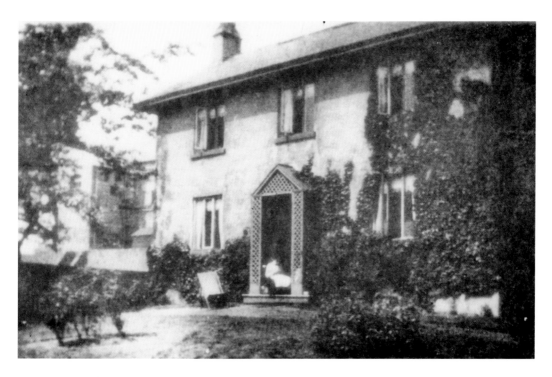

Crosspool Cottage

This cottage stood at 477 Manchester Road on a site which now is part of Cairn Home. In 1964, it was bought by Sheffield Royal Society for the Blind and used as the warden's house. It was demolished in 1993 and the site transformed into a sensory garden for the enjoyment of the sight-impaired residents of Cairn Home.

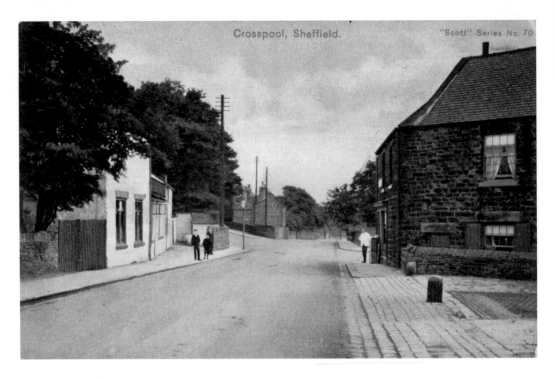

The Crosspool Tavern

The original tavern was part beer house, part workshop. It was demolished in 1930 and the new tavern built behind. The old milestone seen on the right of the old photograph has been incorporated into the surrounding fence of The Tavern Service Station.

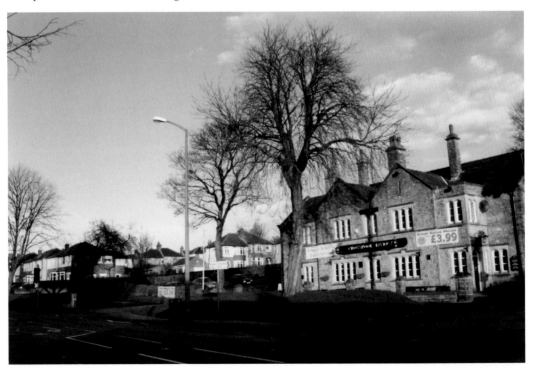

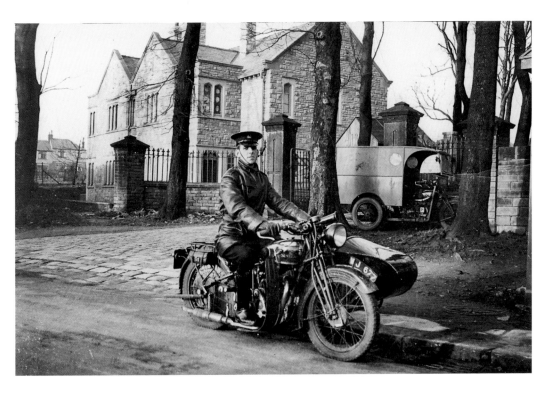

Lydgate Hall Gateway
A motorcyclist waits near the entrance to Lydgate Hall in 1933. The new Crosspool tavern has caused the demolition of the Lodge to the Hall. The gateposts can still be seen between the pub and Motorworld.

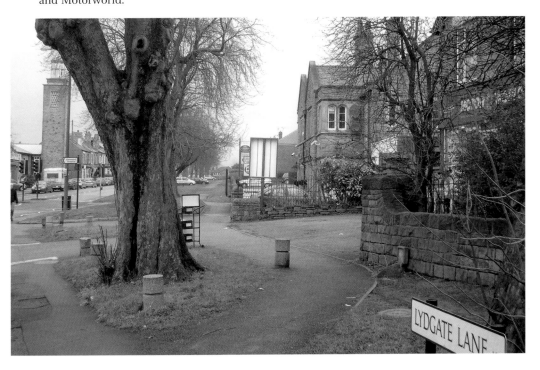

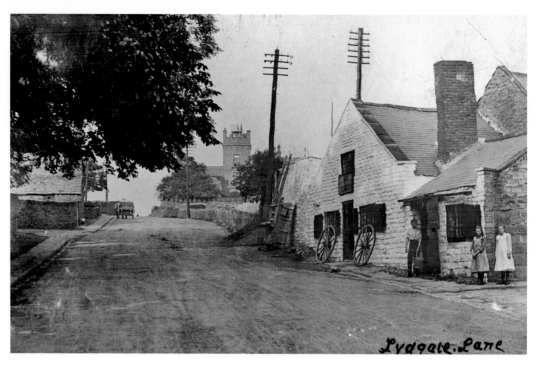

The Smithy

John Bly's smithy was situated on the top corner of the junction of Tapton Hill Road and Lydgate Lane. Wesley Tower can be seen in the background.

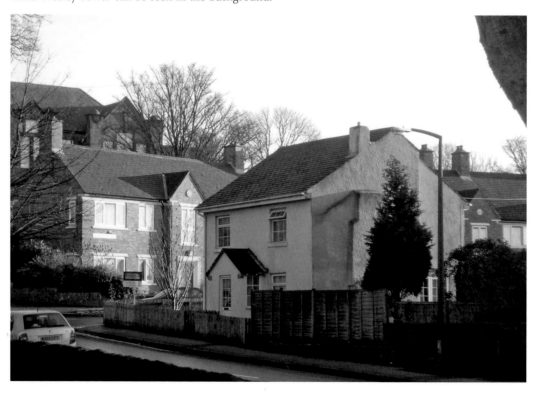

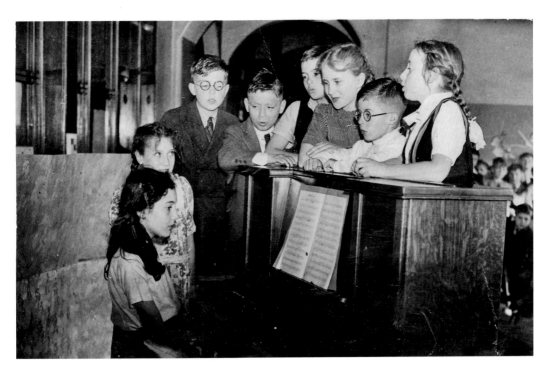

Lydgate Lane School
Opened in 1907, the school taught children of all ages; it now houses infants only. The old photo shows pianist Mary Hopkinson and singers — Rosalie Green, Robert Wheeler, Yvonne Jenkinson and others around the piano in 1948.

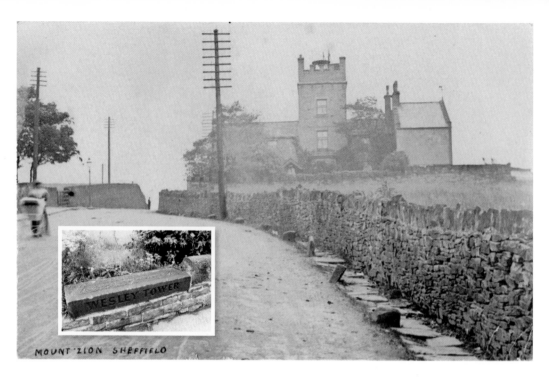

MOUNT ZION SHEFFIELD

Mount Zion

Mount Zion was built in the 1800s. It was later known as Wesley Tower and was occupied by the Misses Howlden who brought Methodism to Crosspool. The engraved name stone which was above the gateway has been incorporated into the boundary wall of the bungalow which now stands there.

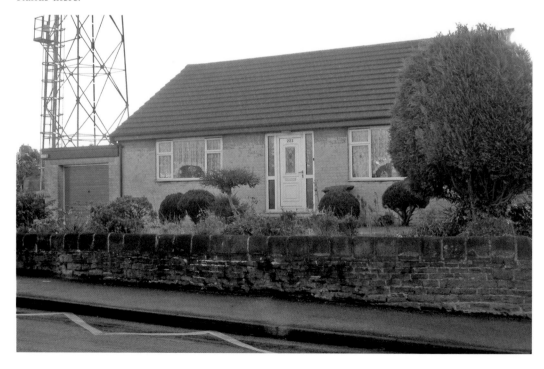

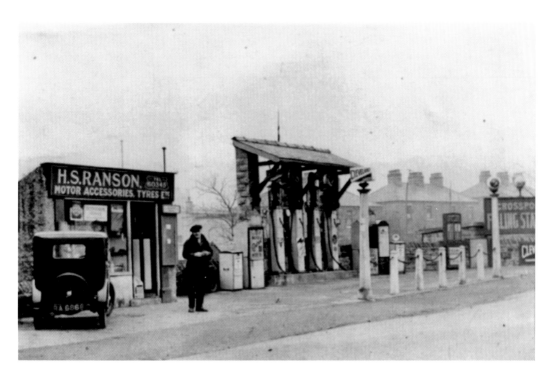

The Tavern Service Station

Originally named Crosspool Filling Station, the garage was owned by the Ranson family who also owned the corner shop. In the 1960s the Fisher family took it on and daughter Sylvia and husband Steven Trees ran it for many years. Although petrol is no longer sold there, the garage is still a busy repair shop.

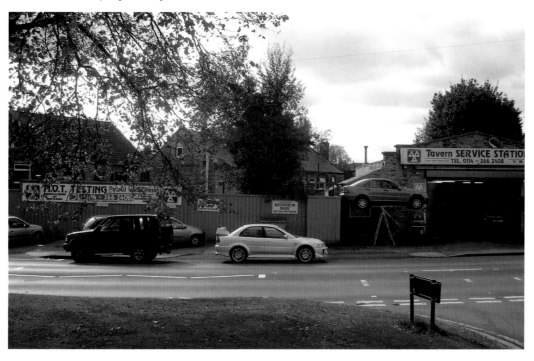

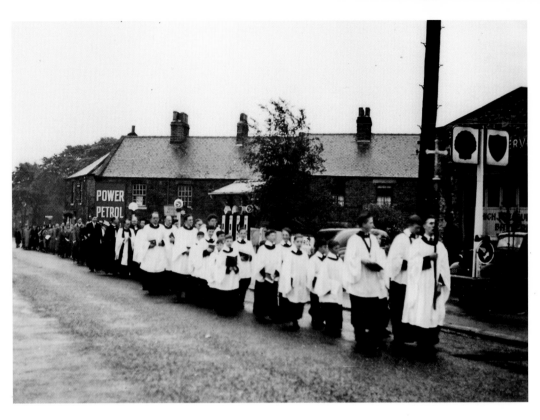

Whitsuntide 1955
The congregation of St Columba's Church is parading to its new church. The service was held under scaffolding! The church tower can be seen in the centre of the new photograph.

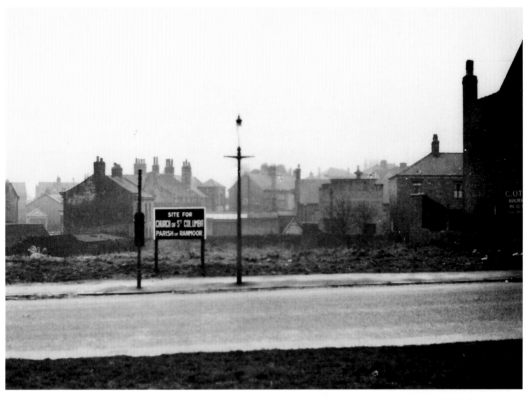

St. Columba's Church

The church was built during the years 1954 and 1955. It was built in an L shape which was quite unusual for the time. The inside space became more useable, being partitioned off for its various functions.

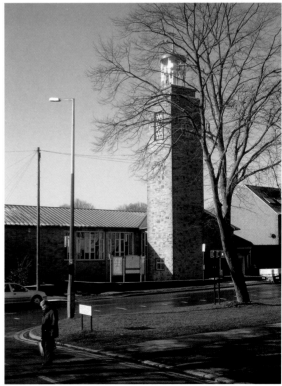

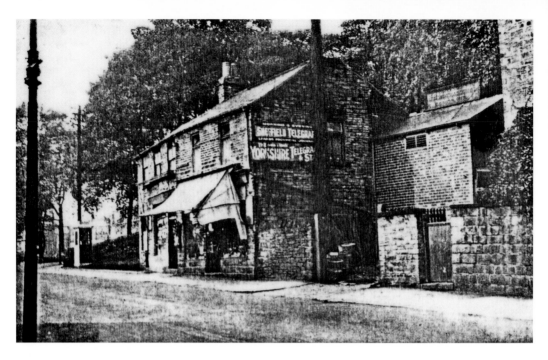

Manchester Road Shops

These shops were built in 1908. They backed onto Lydgate Lane and there were entrances from both sides. Next door, Lydgate House was built in 1812. The corner plot was for many years public conveniences. The eyesore was eventually demolished and replaced by Crosspool Coffee Shop.

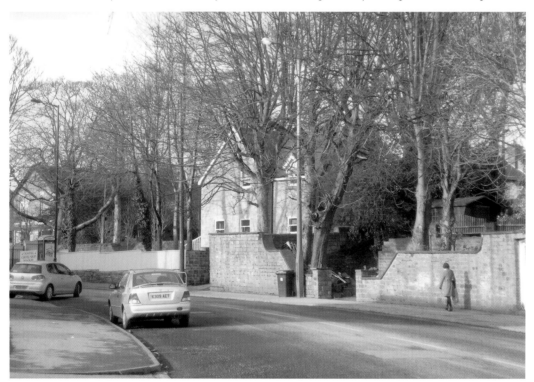

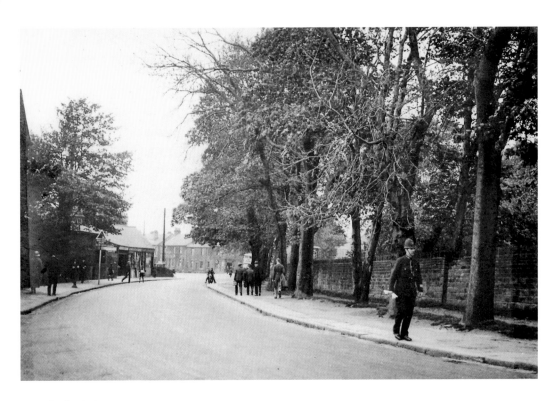

Lydgate Lane

The photo from 1933 shows a policeman walking along Lydgate Lane. He is walking next to the boundary walls of Lydgate Hall. The houses on Sandygate Road can be seen in the background. Some of the old trees have survived and stand next to Lydgate Green.

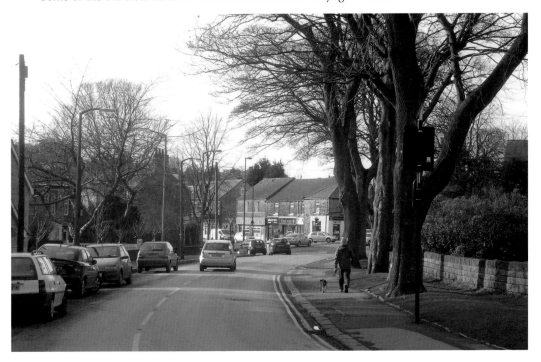

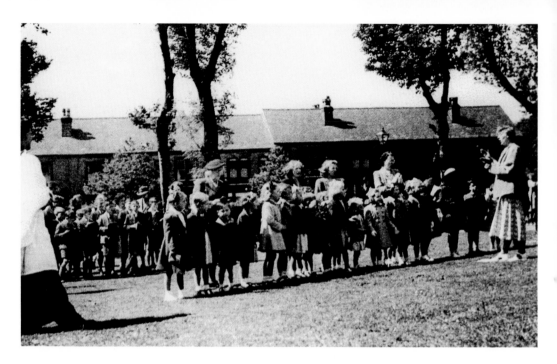

Lydgate Green

The little park which stands on the corner of Lydgate Hall Crescent and Lydgate Lane was a donation by J. G. Graves. It was used for a Whit sing in the 1940s. In 2003, having suffered neglect, local residents with help from the City Council took over the replanting and maintenance of the gardens.

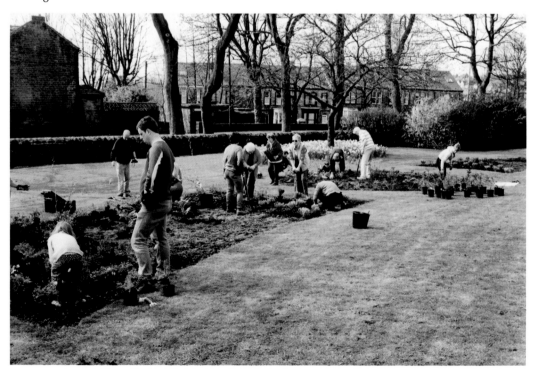

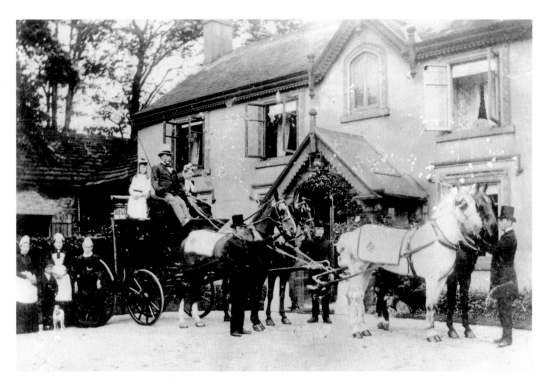

Lydgate Hall

The original hall is believed to date from the 1600s, but most of it was added in the late 1700s. The contents indicated an indulgence of wealth. Its best-known resident was Horatio Bright who lived at the hall in the mid to late 1800s. The land, and eventually the hall were used for redevelopment.

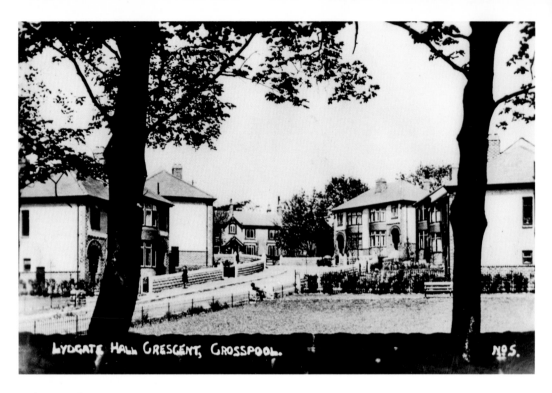

LYDGATE HALL CRESCENT, CROSSPOOL. Nº 5.

Lydgate Hall Crescent

The houses were built in the 1930s, before the Hall was demolished. It can be seen in the centre of the old photo. After demolition the road was completed.

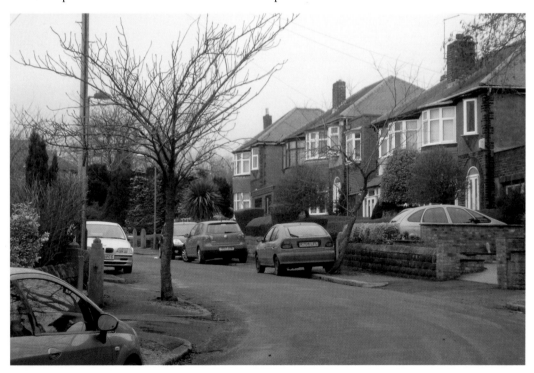

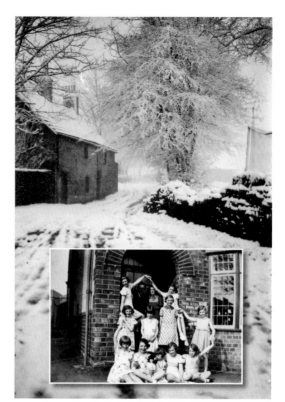

Marsh Lane

The oldest part of Lydgate Hall can be seen on the photograph of Marsh Lane, taken in 1930. Pieces of wall, stone channels, horseshoes and crockery from the hall can still be dug up in the gardens of the present houses. The inset shows Betty Bradbury's birthday party in 1935. Amongst the guests at 8 Marsh Lane are Freda and Jean Rusling.

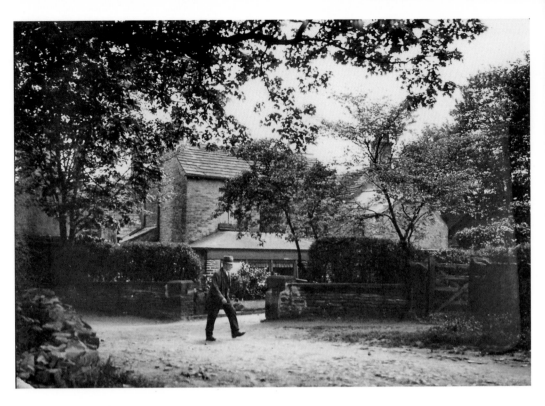

Lydgate Hall Stables
The back of Lydgate Hall and the stable entrance were on Marsh Lane. The present houses at the bend in Lydgate Hall Crescent still have garden access to Marsh Lane.

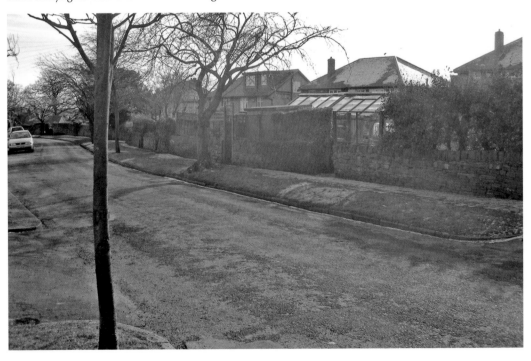

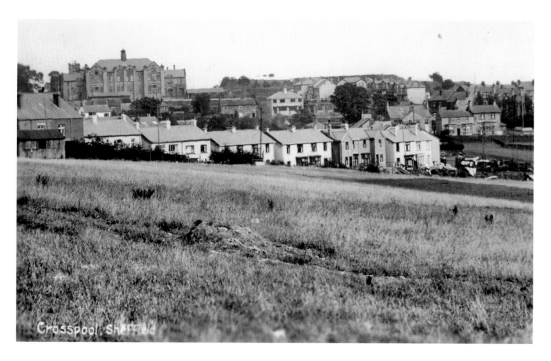

Crosspool From Watt Lane

This view across fields to Lydgate School is almost impossible to see now due to development and tree growth. The Kings Head, now apartments, can be seen on the right.

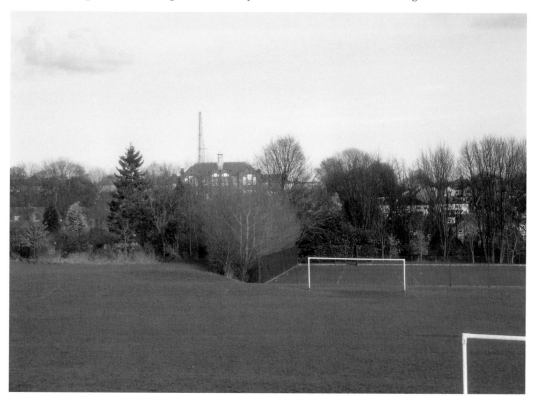

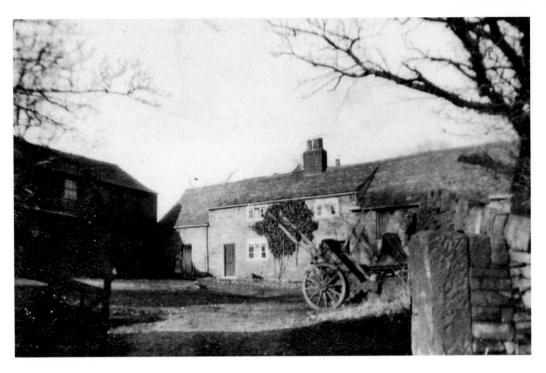

Watt Farm

Watt Farm was known as Storth Farm in 1853 and Cliff Farm in 1893. It was demolished in the 1930s when Dransfield Road was built. Dransfield Road was named after William Dransfield, a civil engineer who lived at Moordale, Ranmoor — now The Fulwood Inn.

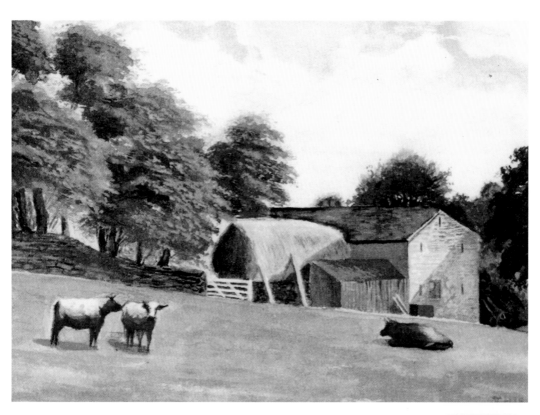

The Stables

The farm on Watt Lane dated from 1635. In Harrison's survey of 1637 it is described as a 'tenement called Storth ffarm with a dwelling house, a barne, a stable and wayne house, an hayhouse and ye yards thereto adjoining'. It stood near the junction of Dransfield Road and Watt Lane.

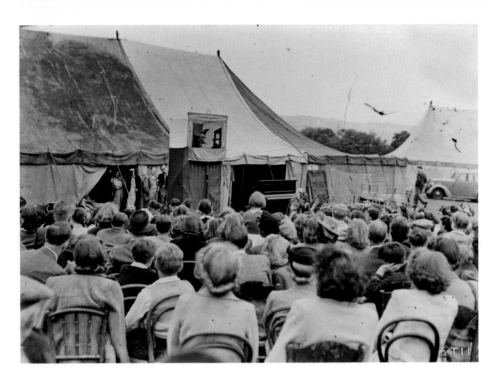

Darwin Lane

For many years a Crosspool gala was held on the playing fields between Darwin Lane and Manchester Road. A Punch and Judy show is enjoyed in 1947. Each summer for the last few years, some of the residents of Crosspool have opened their gardens to raise funds for charity. The Crosspool Summer Fête, organised by the Crosspool Forum, is now held on the sports field on Coldwell Lane.

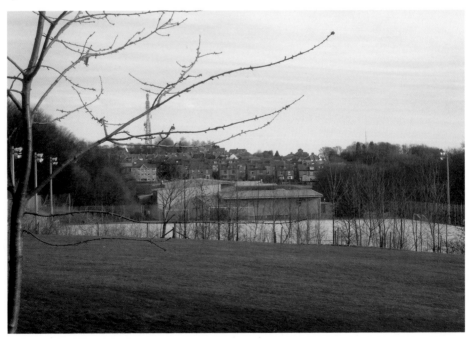

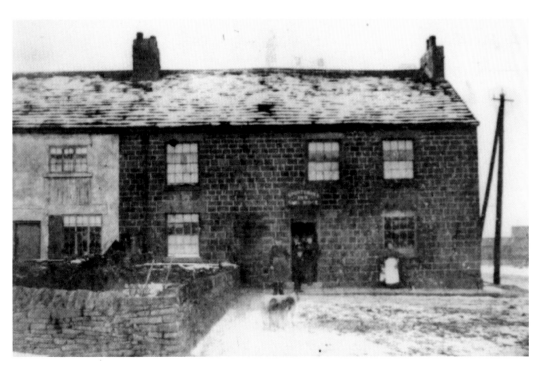

The Sportsman

Originally a row of cottages, one of which became a beer house, The Sportsman was rebuilt at the beginning of the twentieth century. There was a public well behind it. It is now part of the Ember Inn chain.

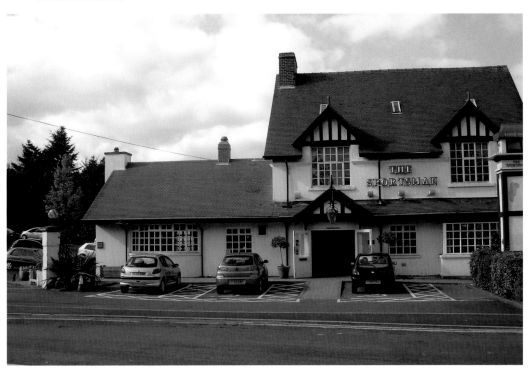

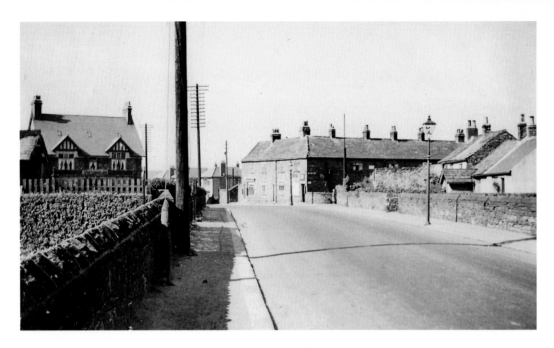

Stephen Hill Shops

The shops, pictured in 1928 stood on Manchester Road at the corner of Stephen Hill. One of the shops was owned by Mr and Mrs Allis, grandparents of Peter Allis the golfer. They had a large garden and greenhouse and sold their own produce to local people. Opposite the shop was an adit or opening to a coal mine.

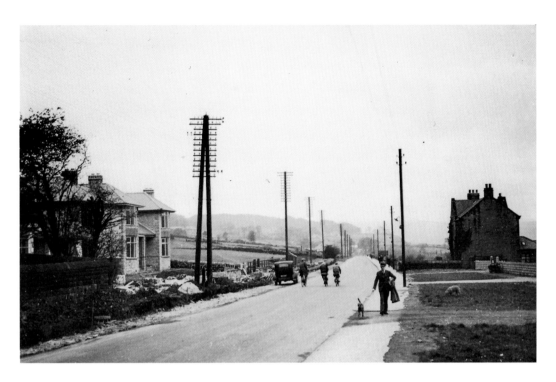

Towards Rivelin

A view of Manchester Road taken in 1933. The houses were being built, but some farmland remains. Moorview Farm is seen on the right. Note the interesting telegraph poles.

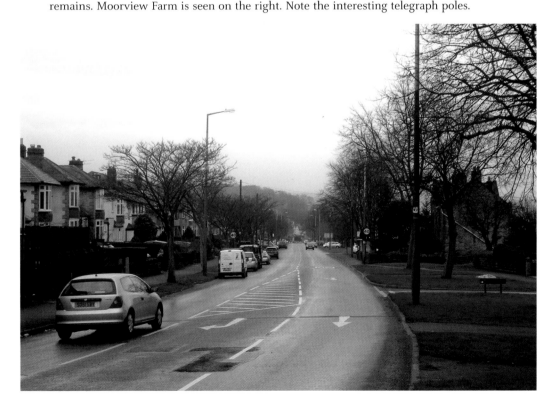

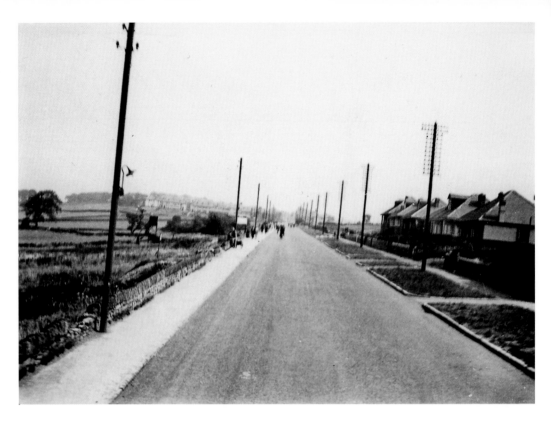

New Developments

The view of Manchester Road in 1934 shows the first houses being built on the right hand side of the road. Much of the undeveloped land belonged to Hagg Farm. There appears to be no street lighting.

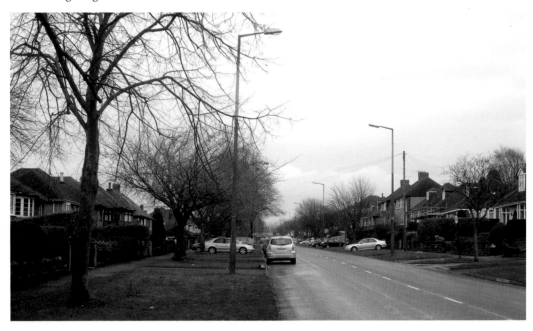

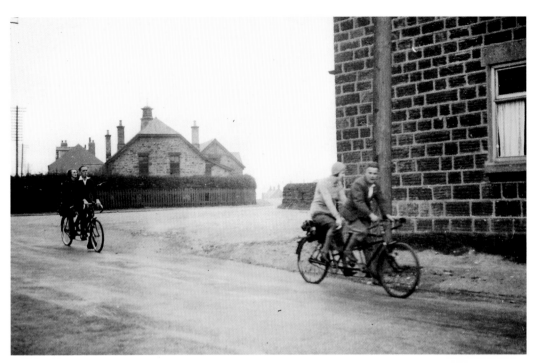

Stephen Hill Church

Stephen Hill Church, originally using buildings on the opposite side of Manchester Road, moved to its present position in 1896. It was extended in 1953 and the new entrance, forum and other improvements were completed in 2003. The tandem riders pass The Sportsman with the church in the background in 1932.

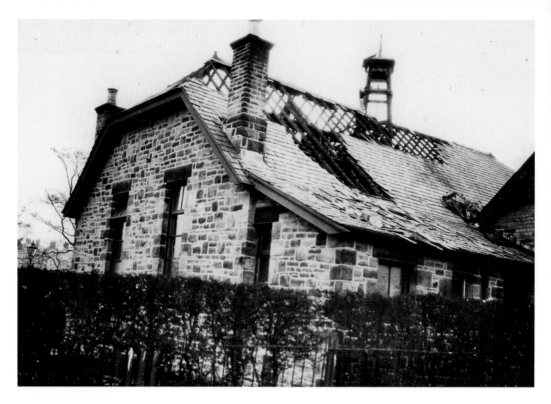

The Fire

In 1933 the roof of Stephen Hill Methodist Church was damaged by fire. This necessitated repairs to the roof, electrical wiring and furniture. It was damaged again during the Second World War when a bomb dropped on houses on Ringstead Crescent. There was a public air raid shelter under the church.

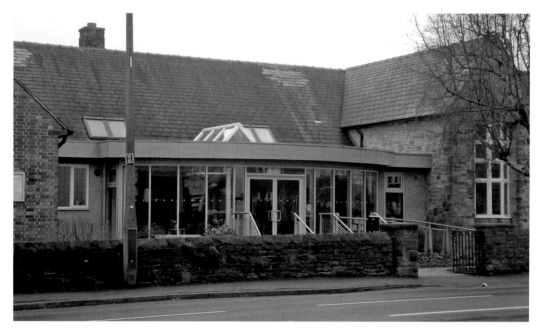

Delph House Road

A newspaper article of 1938 describes Crosspool as 'being high up, it is extremely cold in the winter, and winds from all quarters beat upon it . . . however the people of Crosspool not only survive, but thrive on their wintry conditions. Winds make them cold, but they also make them hardy'. The houses seen here in 1929 had just been built. The present day photograph was taken on a rare snow free day in January.

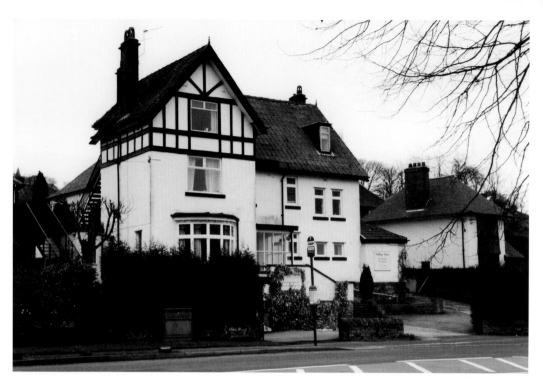

Cloncurry

709 Manchester Road was built as a private house in 1922. In later years it became a residential home for the elderly. In 2005 it was demolished and replaced by a small apartment block.

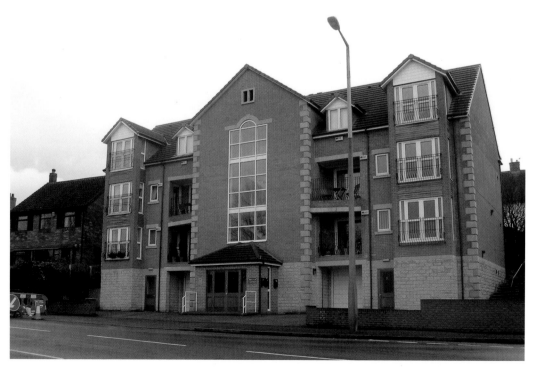

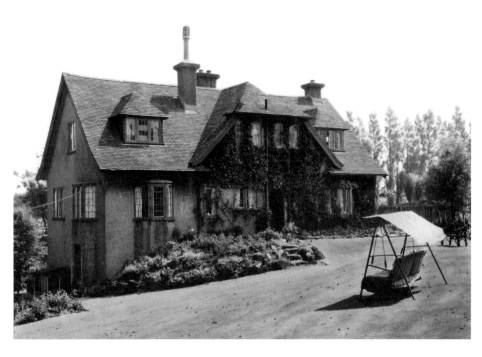

Den Bank House
This lovely house was built in the 1930s. In 1952, the date of the photograph, Mrs Ethel Mayhew lived there. It featured in an interior design magazine.

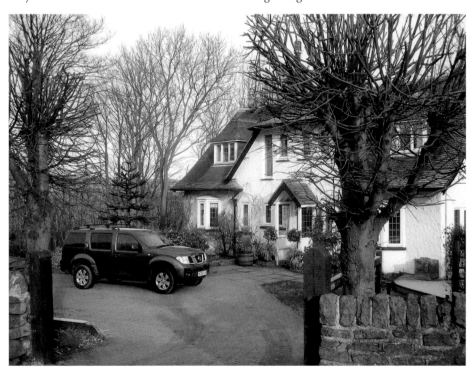

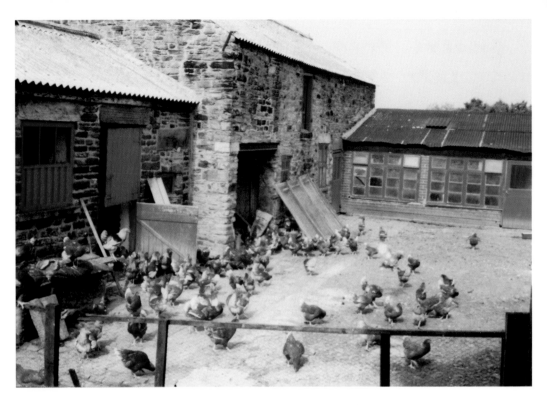

Moorview Farm

The house in its present form dates from 1850, but a farm stood there earlier. A map of 1895 shows Hallam colliery in the fields behind. Little has changed in recent years apart from the farm standing empty and awaiting its future.

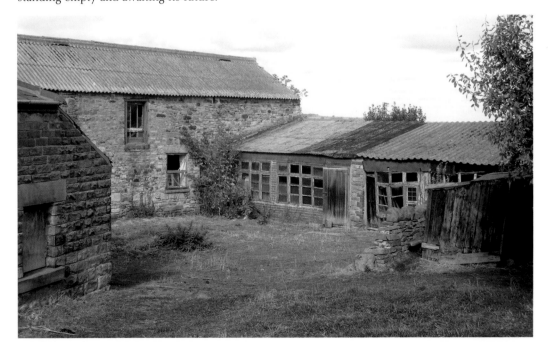

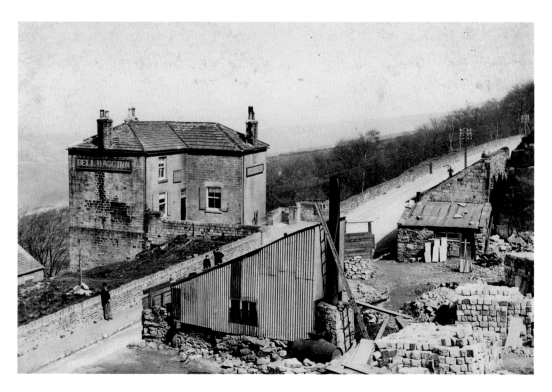

The Bell Hagg Inn

In 1832 this unusual five-storey building was built by Doctor Hodgson. It is said to have been built to antagonise the vicar of Stannington church which stands at the opposite side of the valley. The pub was known as the John Thomas for a few years, but reverted to its original name. It has stood empty for some years and awaits development.

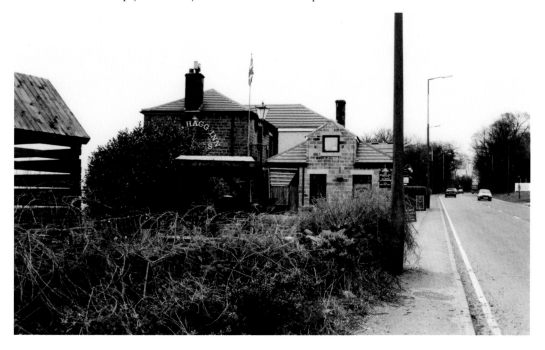

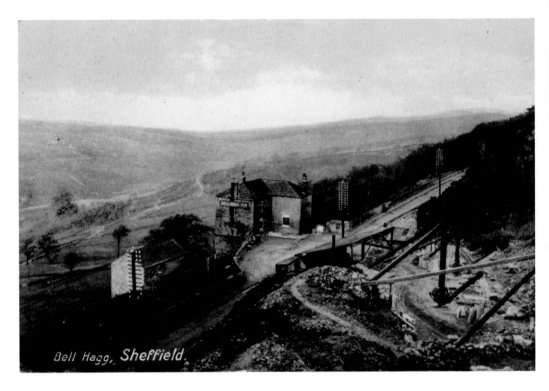

Bell Hagg Quarry

Opposite the inn can be seen the entrance to the sandstone quarry. It was worked from 1905 by the brothers Herbert and Ernest Andrews, although the land was owned until 1921 by Christopher Leng who lived at the Towers on Sandygate Road. In 1970 the business ceased and the site was turned into a garden centre and caravan storage.

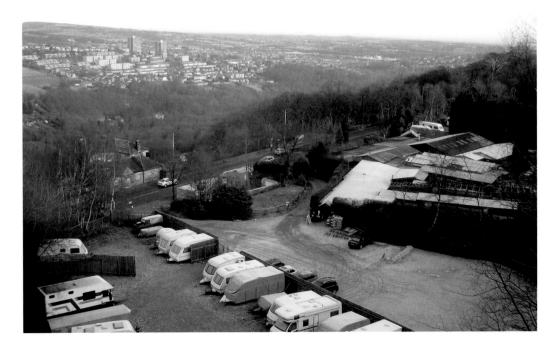

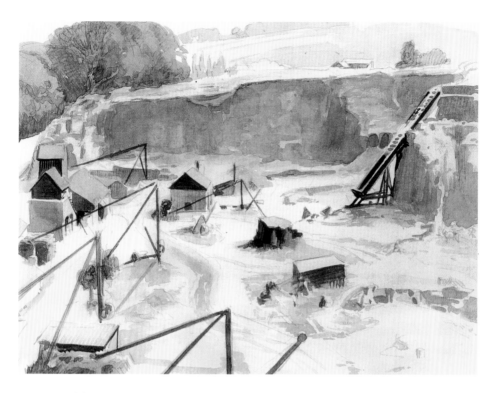

Owen Bradshaw

This watercolour study was done in 1946 by Owen Bradshaw. It shows the workings of Bell Hagg Quarry. Owen Bradshaw was sub-editor and cartoonist for the *Weekly Telegraph*. His sketches were made on his frequent walks around the area, looking for inspiration for his Gloops cartoons in the *Star*. The café in the garden centre opened in 2009.

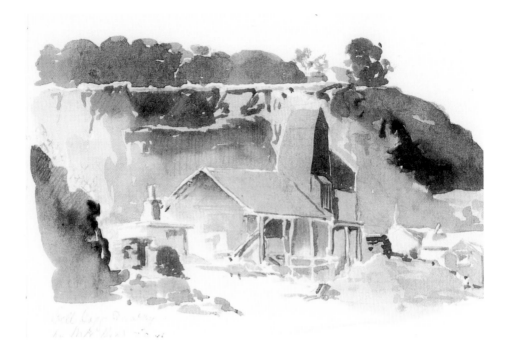

The Crusher

The crusher was an important part of the quarrying process. Large pieces of rock were pushed in at the top, were shattered into smaller pieces, eventually passing through the exit at the bottom of the pit. Stone flags and fireplaces were among the products of the quarry. At the top of the present day photo the flats on Moorbank Road can be seen. In 1946 the area was still wooded.

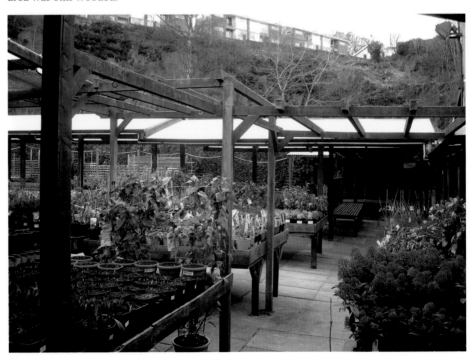

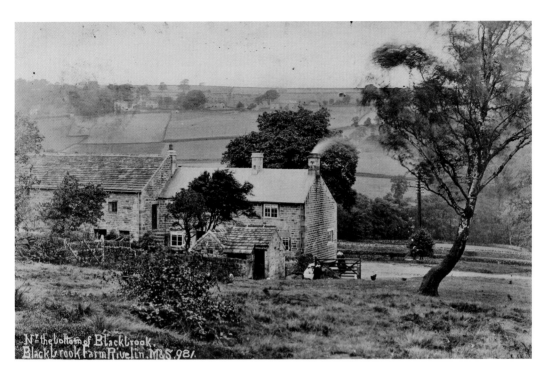

Blackbrook Farm

Blackbrook Farm comprises the farmhouse and four acres of land. The house was built in the 1750s. For a short while in recent years it housed The Café in the Coppice.

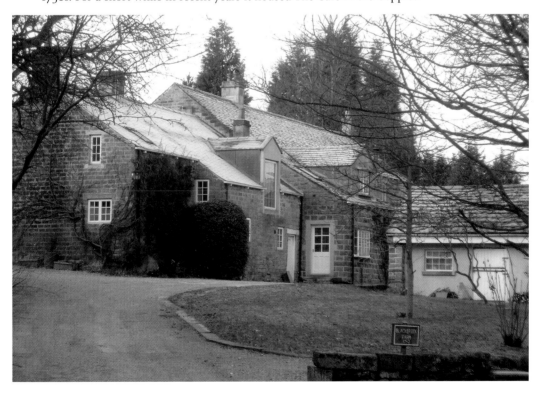

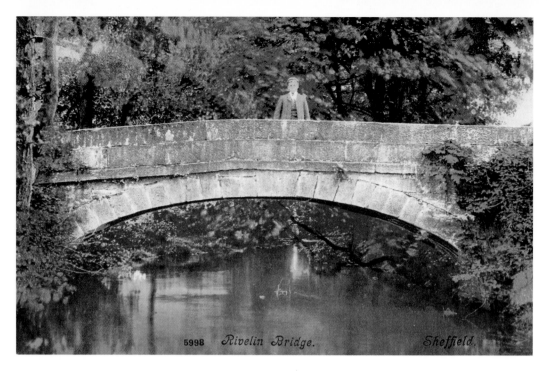

5998 Rivelin Bridge. Sheffield.

Rivelin Bridge

The packhorse bridge was constructed in 1794. Little has changed since the early photo. It is now a very tranquil spot, the traffic being taken by the bridge on Rails Road.

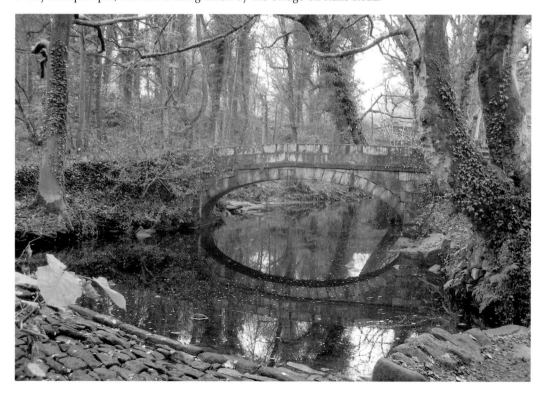

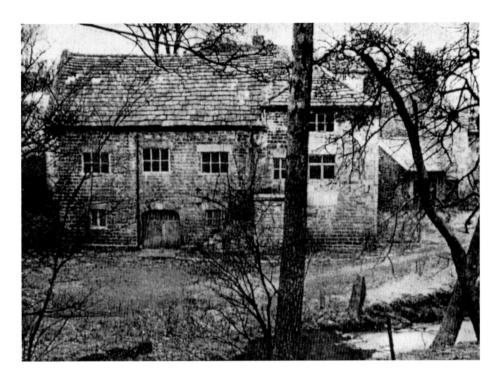

Rivelin Corn Mill

The corn mill stood on the site of Rails Road car park. It is believed to have dated from 1600 when it was owned by the Earl of Shrewsbury. It was demolished in 1950. Thanks to the hard work of Rivelin Valley Conservation Group and with help from the City Council the millpond has been restored and is a haven for wildlife and a pleasant picnic spot.

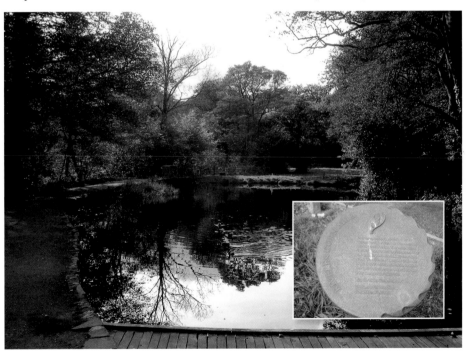

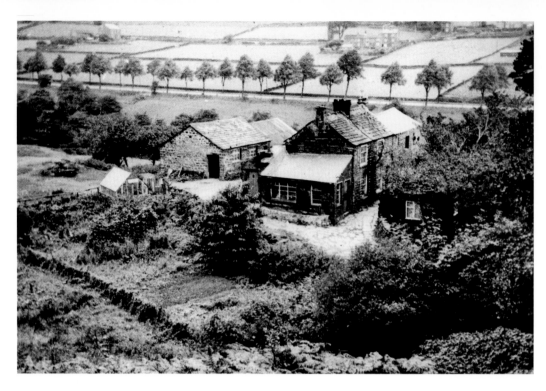

Samehill Farm

In 1816, the present farm was built by spring knife cutler, Thomas Birks. On the map of 1895, the farm is marked as Samel Yard. Tree growth makes the present view of the house quite difficult to see.

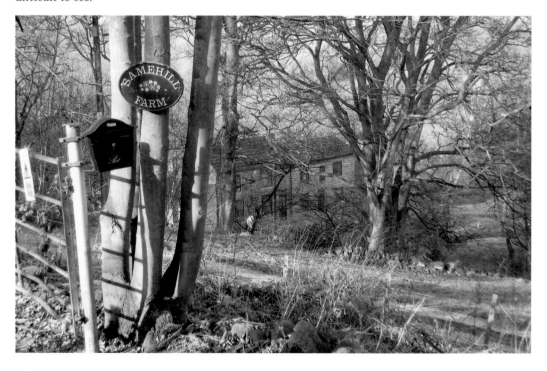

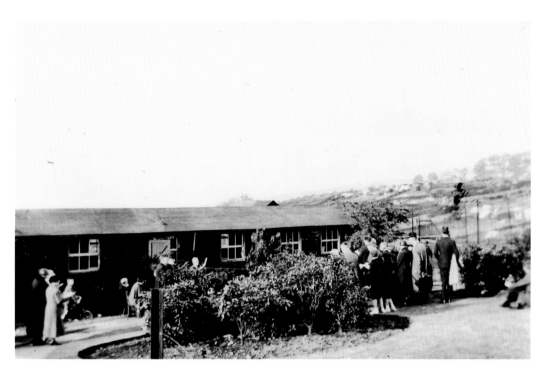

Carver Fields

Carver Street Methodist Church Sports club occupied this site from the early 1900s until the 1950s. It was one of the most prestigious sports clubs in the city. Shown on the photograph is the opening of the pavilion in 1921. Although no longer a sports facility, the fields are much enjoyed for their open spaces, wildlife and views across Rivelin Valley.

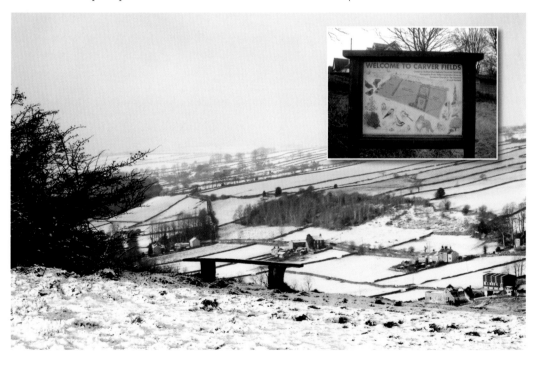

Sporting Moments!
Carver Fields is still owned by the
Methodist Church but maintained by the
Rivelin Valley Conservation Group. The
top field is used for general recreation, the
middle field (formerly tennis courts) is
returning to nature to encourage wildlife,
and the bottom field is a wild flower
meadow. The photographs show Sarah
Rusling ready for tennis in 1963 and Jeremy
Youle and Laura Cottom trying out their
cricket in 2004.

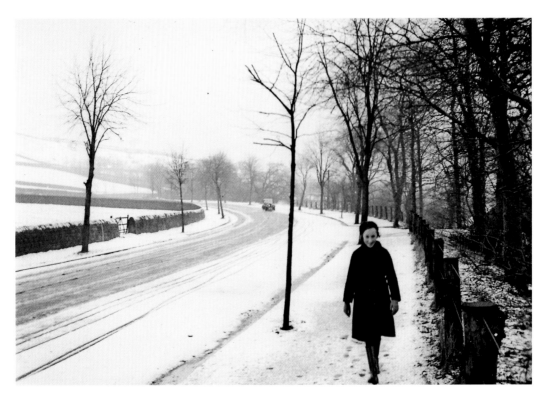

Rivelin Valley Road

In 1905 this road was built, providing work for 176 unemployed men. It was for many years known as the New Road. In 1906, 700 lime trees were planted. Bessie Walker is seen enjoying her walk in the late 1920s. Today the trees are somewhat larger!

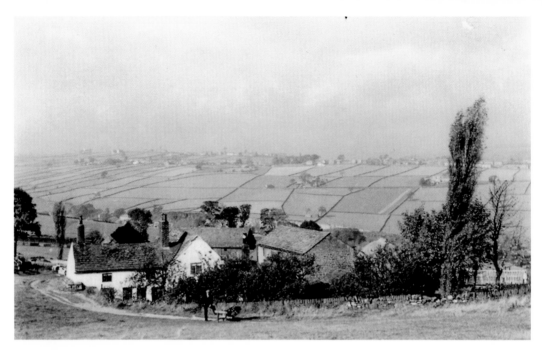

Hagg Farm

Hagg farm stood on a site on Den Bank Drive. It was cleared in 1952 to build houses. Many houses were built in the Den Bank area in the 1950s and '60s.

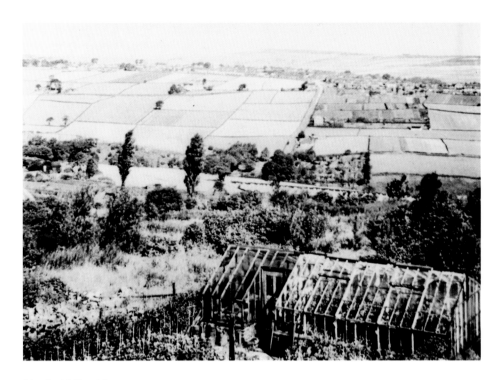

Rivelin Valley View

The view from the back of houses on Den Bank Crescent looks towards Hagg Farm and across the valley to Stannington. In the 1950s the popularity of gardening was a reminder of the shortages and rationing during the Second World War. Development on the Stannington side of the valley looks much the same at this point.

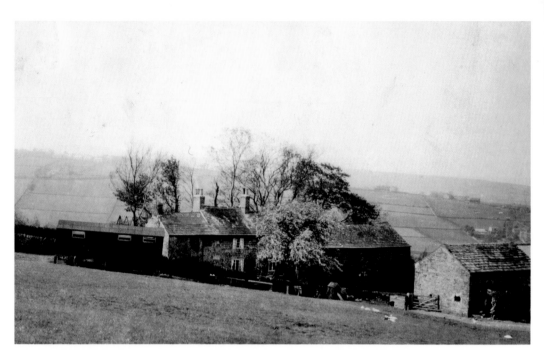

Hagg Lane Farm

As opposed to Hagg Farm, Hagg Lane Farm actually stood on Hagg Lane! It stood just below the entrance to the present Den Bank Drive.

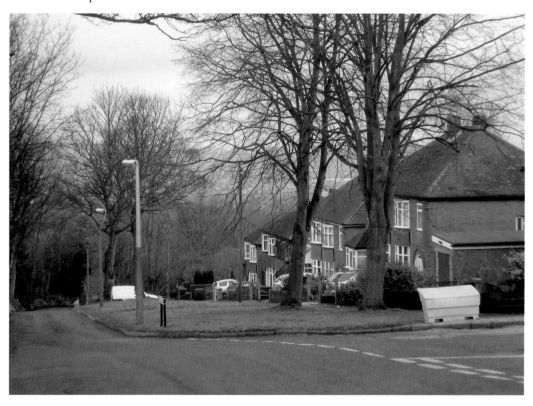

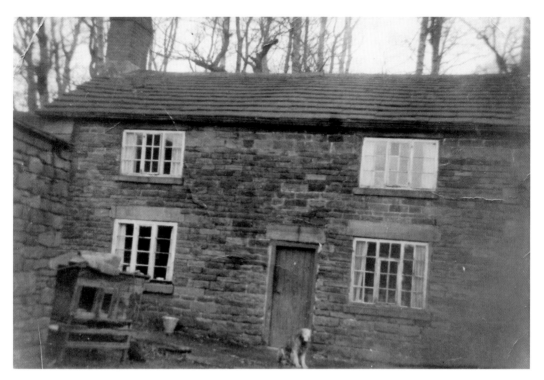

Delph House Farm

To reach the site where Delph House Farm once stood, the path beside the allotments from Marsh Lane has to be taken. The farm stood in the fields above Clough Fields. Built in 1712, it was occupied by the Twigg family for many years, until it was demolished in the 1960s. The insert shows Mr Twigg in the farmyard.

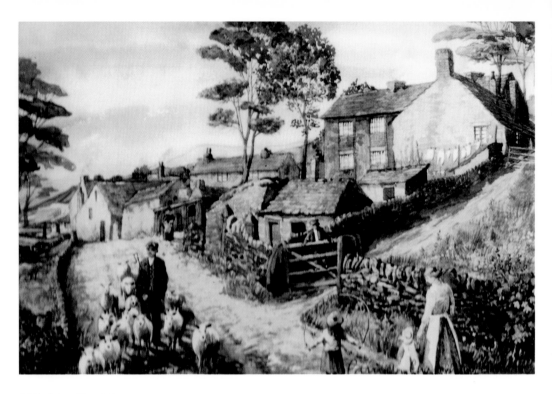

A Thriving Hamlet

Clough Fields was once a thriving hamlet of fourteen families. For many years, the hamlet was occupied by cutlers, grinders, farmers and miners-extracting coal from the Hallam bed of coal. Today Clough Fields houses a cat hotel and livery stables. The artist is unknown.

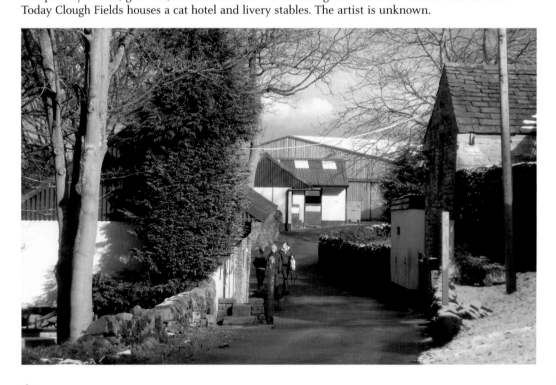

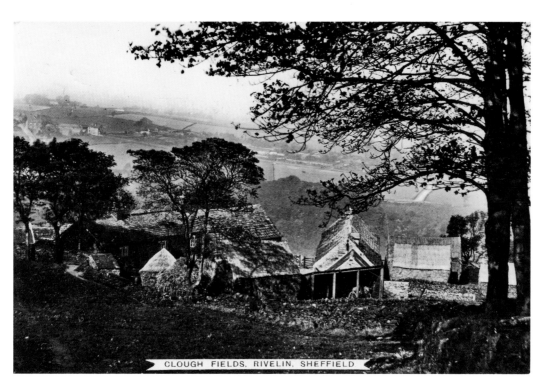

CLOUGH FIELDS, RIVELIN, SHEFFIELD

Clough Fields

The postcard shows the hamlet in 1912. The hills of Stannington are sparsely developed, compared with today's view. Clough Fields however is much smaller than it once was.

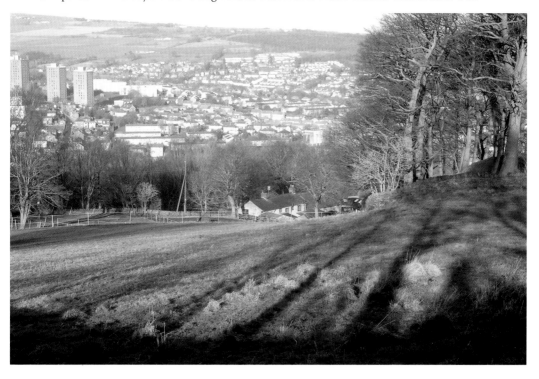

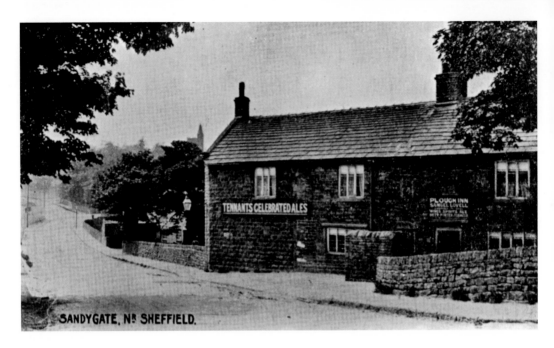

SANDYGATE, Nr SHEFFIELD.

The Plough Inn

Originally built in 1695, The old Plough Inn was demolished and replaced by the present building in 1929. It stands opposite Hallam Football Ground — the oldest football ground in the world! On both photographs can be seen The Towers — once the private home of Christopher Leng, built in 1896.

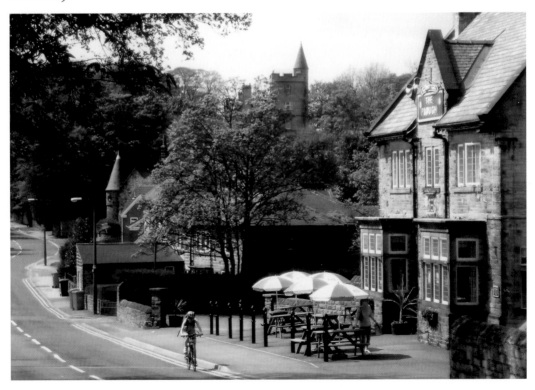

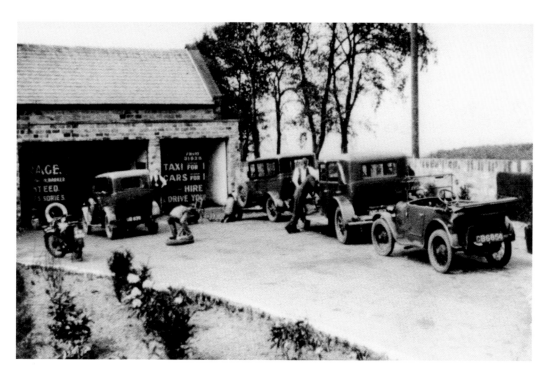

Sandygate Garage

The Plough Inn had stables attached to it. In 1935, they became Barker's Garage. The business grew and eventually became Sandygate Motors. It was sold in 1999 and St Francis Court was built in its place.

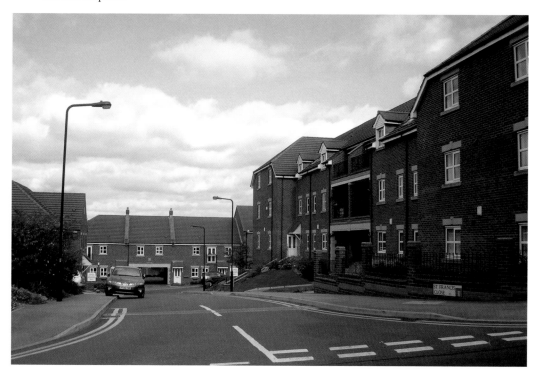

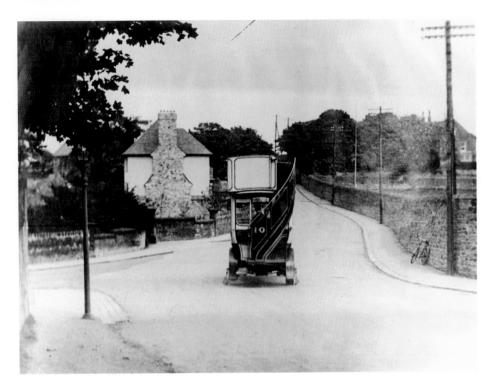

High Green

The area near The Plough Inn was known as High Green (as opposed to Nethergreen to the south). There was a cross on this site, which was probably a way marker. The bus service to Lodge Moor began in 1913. Here the bus can be seen at the junction of Sandygate Road and Coldwell Lane. Hallam Football Club is on the right.

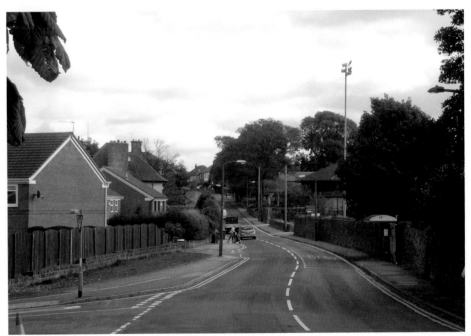

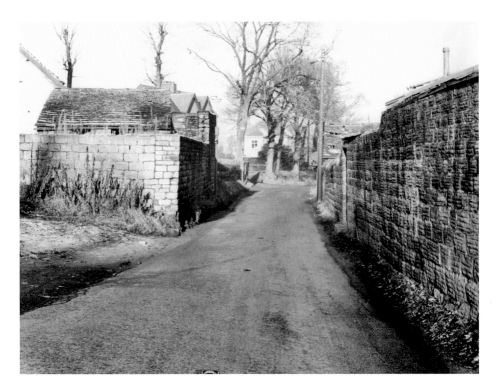

Coldwell Lane

In 1960 Coldwell Lane was still a fairly quiet road. On different maps it is marked as Hagg Lane, Hagg Road and even Bell Hagg Road. It was often called Dairy Lane, referring to the model dairy built by Christopher Leng. The dairy, seen on the left in the recent photo is now a private house.

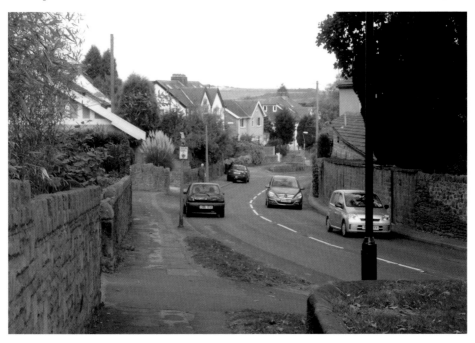

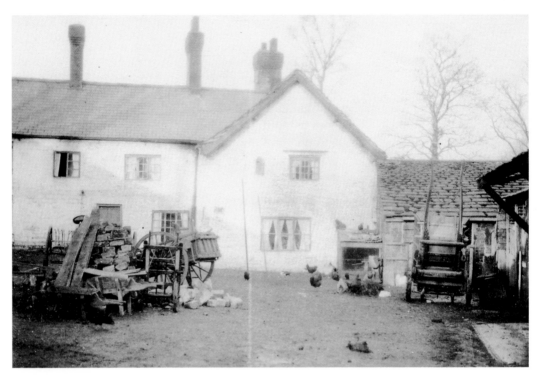

Moorbrook Farm
The farm, which stood at 5 Coldwell Lane, was partially demolished in 1967. The original building had the date of 1681 on the gable end.

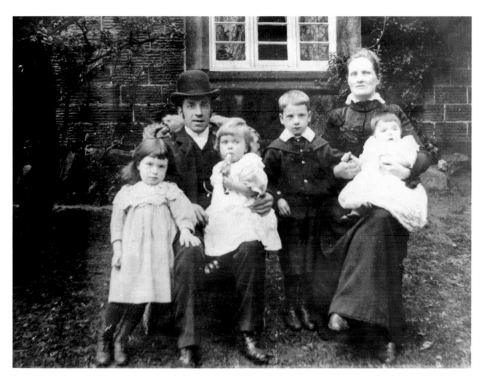

Burntstones Lodge

In 1900 the lodge was the home of George and Emma Plant and their family. The crosses on the gatepost are thought to refer to Daniel Holy who lived in Burnstones Hall in the 1800s.

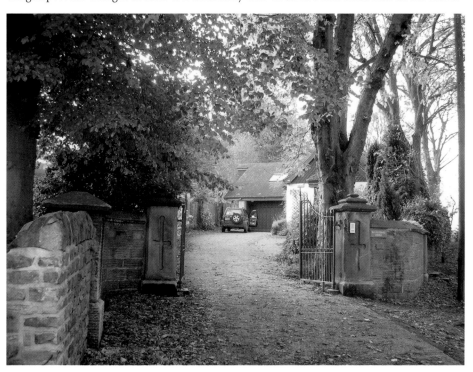

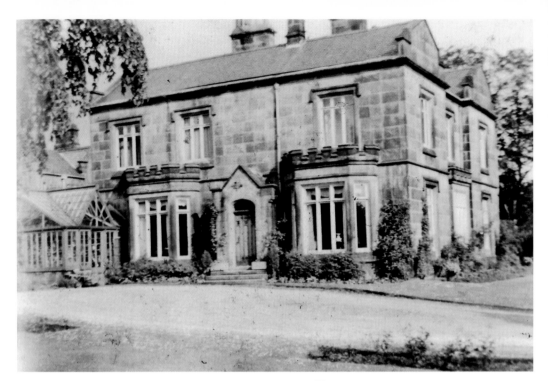

Burntstones Hall

The house shown in the photo is thought to have been built in the early 1800s, although a property stood on the site for many earlier years. The grounds stretched from Redmires Road to Moorbank Road. The house was demolished in the 1960s, when the Burnstones and Sandygate Park houses were built.

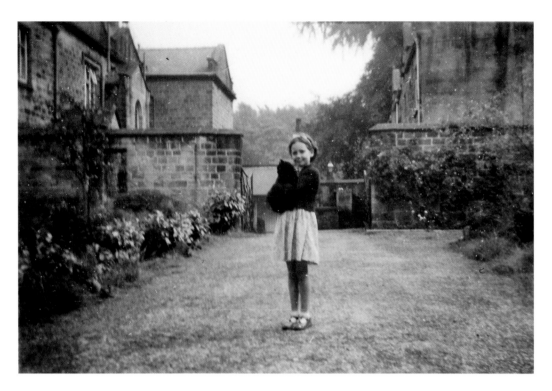

Burntstones Hall Stables
In the 1950s the hall was occupied by the Mitchell family. Here, in 1956, Hannah Mitchell and Inky are seen in the stable yard. There were many out buildings. Some walls and trees from the grounds remain.

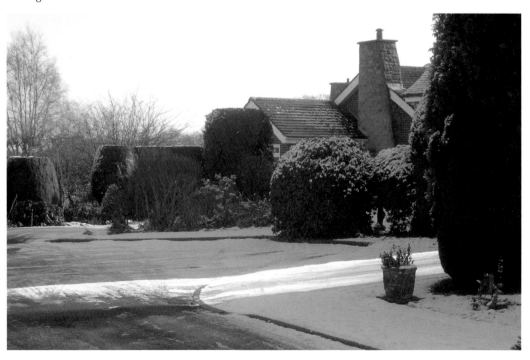

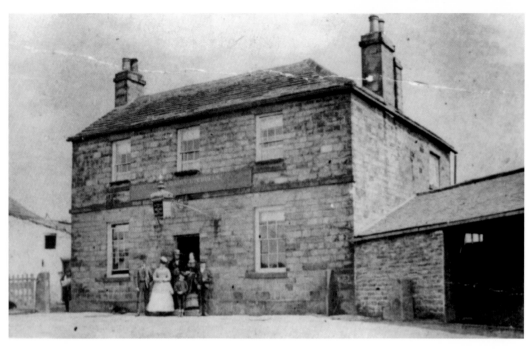

The Kings Head

The first purpose built inn in Crosspool was the Kings Head. It was built in 1829 and was originally a square stone building with a stable, or wagon shed set at an angle to the main building. Despite local protests, the pub was demolished in 2001 and replaced by retirement flats.

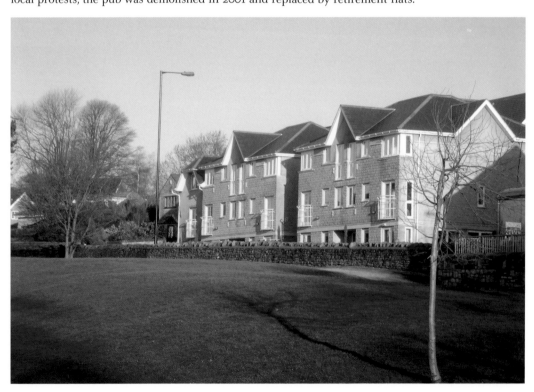

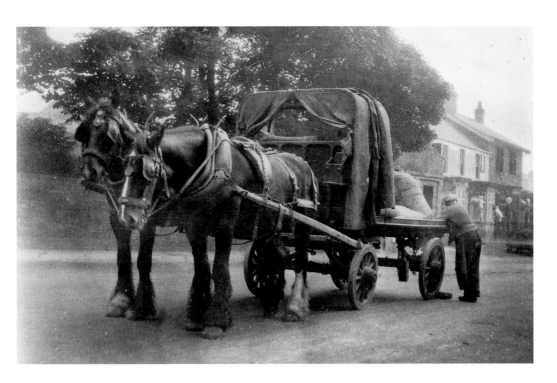

Road Transport

Behind the miller's cart, photographed in 1932 can be seen the Kings Head pub. The Manchester Road /A57 is now a busy route through Broomhill, Crosspool and on towards Manchester. This spot becomes particularly busy at school times, the nearby bus stops serving children from the four nearby schools.

Tapton Rise Farm

On the corner of Shore Lane and Manchester Road, stood Tapton Rise Farm, also known as Bingham's farm. It was demolished in 1974. In 1975 Lydgate Junior School was built. A popular and successful school, its open plan design was unusual for its time.

The Playing Fields

The farms fields are now playing fields serving Lydgate Junior and Tapton and King Edward VII comprehensive schools. The early colour photo, from 1936, taken by Mr Drury who lived opposite the fields, shows a rather idyllic scene of haymaking.

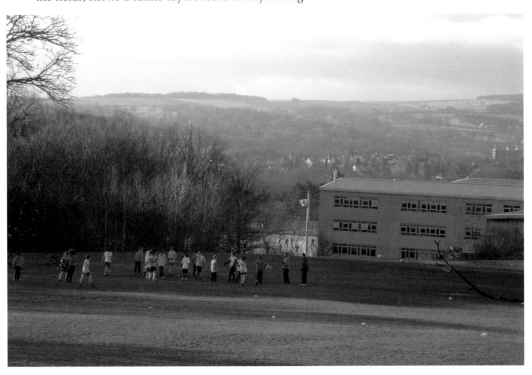

The Conduit
Seen on this snowy photo from 1931 is the conduit which carried water from the dams at Redmires. After demolition the land was levelled using land fill.

Manchester Road

Another snowy photo, this time from 1933, shows Manchester Road near the junction with Tapton Hill Road. On the left is Tapton Hill Congregational Church, the oldest church in Crosspool.

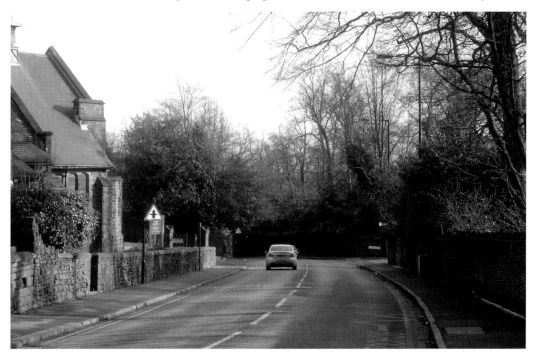

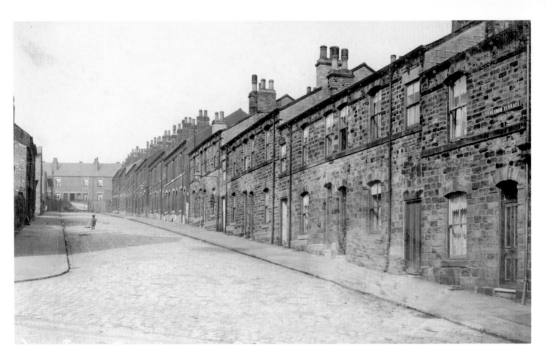

Vernon Terrace

The photograph from 1900 shows the terraced houses on the right hand side of Vernon Terrace. They, along with those on Tapton Hill Road were demolished in the 1970s. The upper part of the road remains the same.

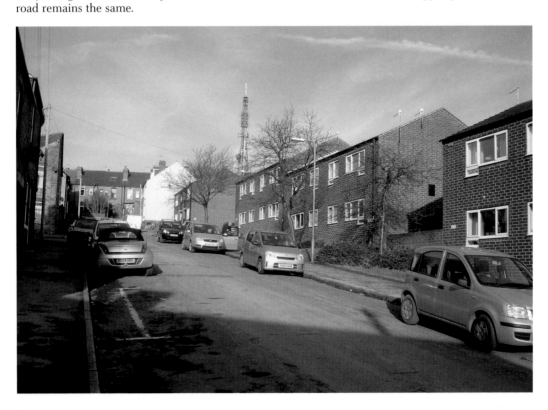

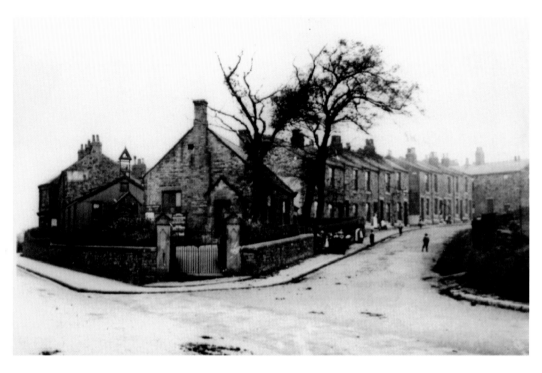

Tapton Hill Congregational Church
Founded in 1853, the present church building dates from 1875. The old houses on Tapton Hill Road were replaced in the 1970s by council flats.

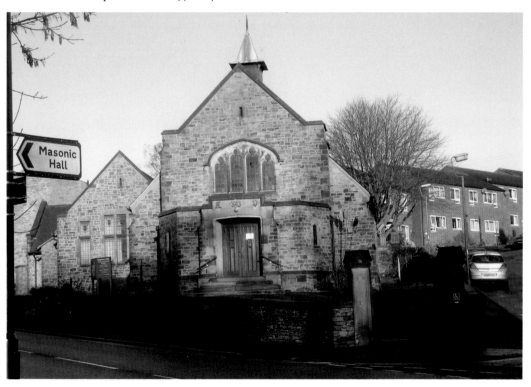

Tapton Bank

The lower part of Tapton Bank has changed little since being built in the late 1800s. In the 1930s it was extended to cross Tapton Hill Road, and modern semi-detached houses built. Mrs Carter, later Gosney is pictured outside her house.

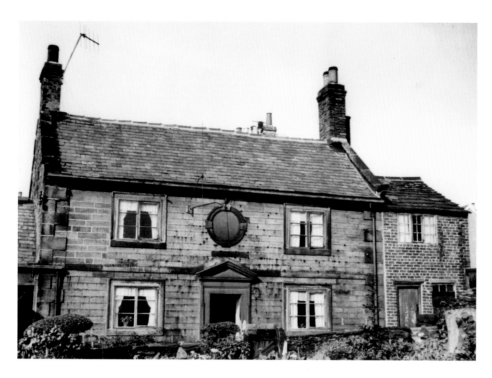

Rose Cottage Inn

The inn was built in 1755 and as its name implies was originally a cottage. It stood where 83-85 Tapton Hill Road now stand, one of the present houses retaining its name.

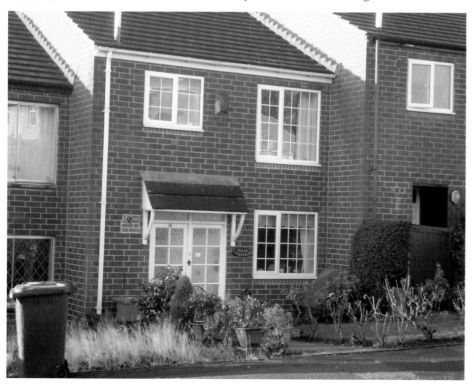

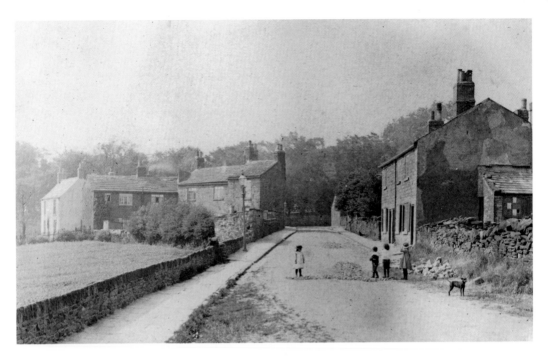

Tapton Hill Road
Tapton Hill Road was once one of the main routes through the area. Nowadays the traffic comes from the Royal Mail Sorting Office on the left and from nearby Lydgate Infant School.

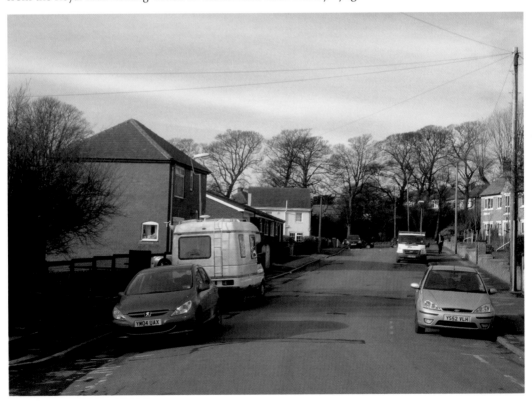

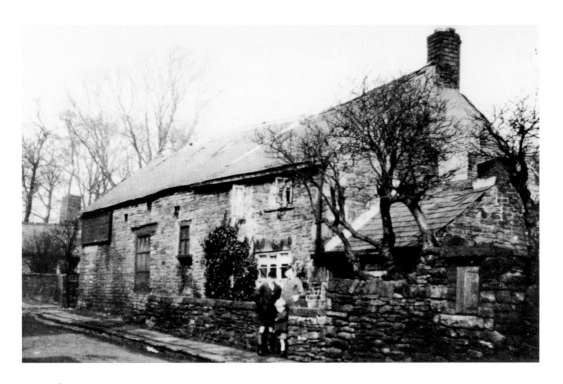

The Cottages

The Hague family occupied one of the cottages on Tapton Hill Road for many years. They were demolished in the 1930s and replaced by Graves Trust Homes, now maintained by the City Council. In the background can be seen the chimney of the Smithy on Lydgate Lane.

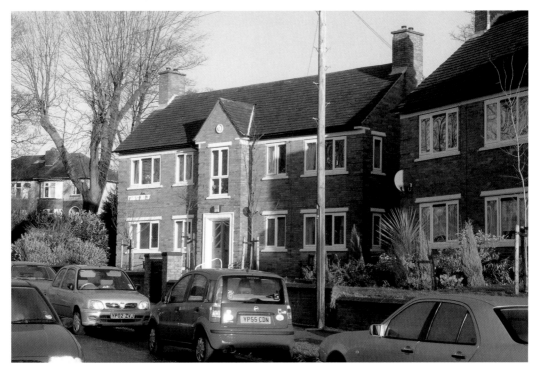

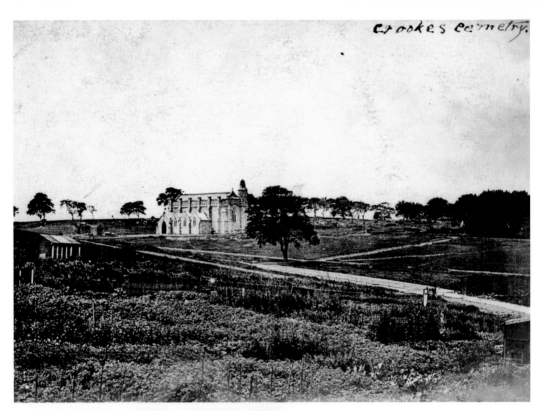

crookes cemetry.

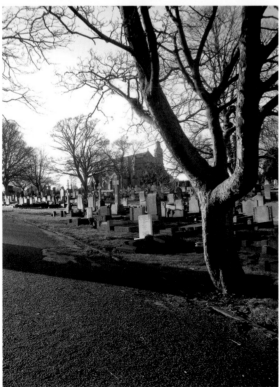

Crookes Cemetery
The cemetery was officially opened in 1910. The land was donated by John Maxfield who died in 1906 and was the first person to be buried there.

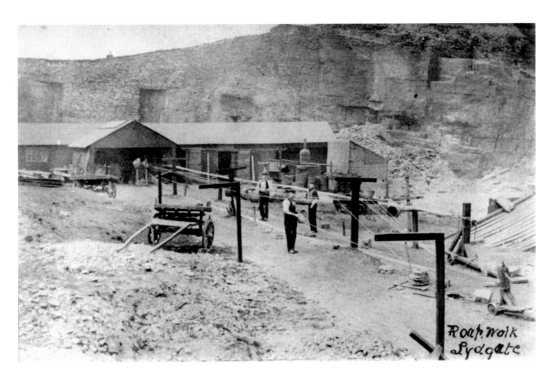

The Rope Walk

There were two quarries on Lydgate Lane — Lydgate Lane Quarry and Lydgate Quarry, also called Mount Zion Quarry. The rope walk was owned by J. H. Mudford and sons. Lydgate Lane Quarry was filled in using rubble from bomb damaged buildings and developed into a children's playground.

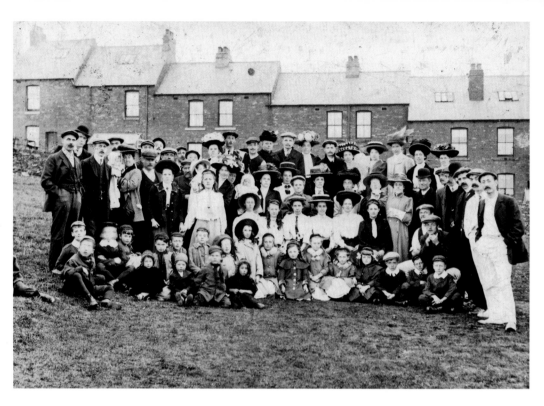

Evelyn Road

The old photo from 1909 was taken in the field at the top of Evelyn Road. The waterworks reservoir is beyond the top of the road. Houses were built on the field in the late 1920s.

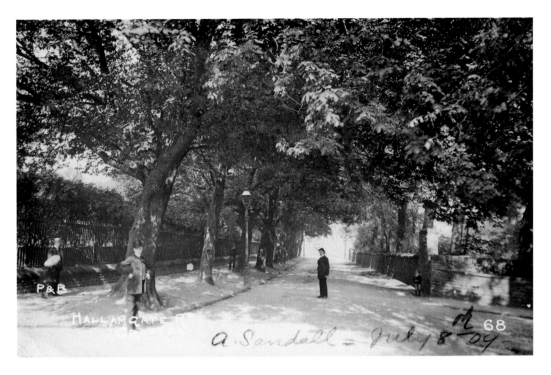

Hallamgate Road

The old photograph is from 1909 and shows the Old Grindstone Pub in the distance. Semi detached houses have been built on the left and Sheffield University Tapton Hall of residence on the right.

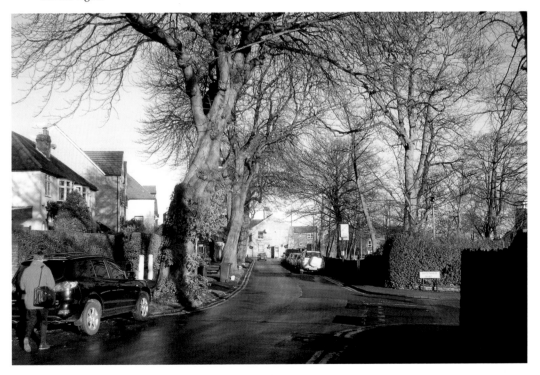

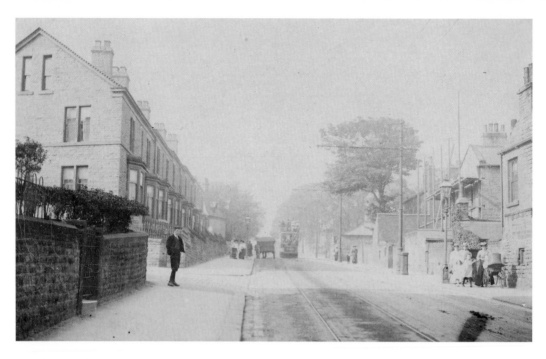

Crookes Road
An open topped tram overtakes a horse and cart on Crookes Road in the early 1900s. The houses look the same now as they did 100 years ago.

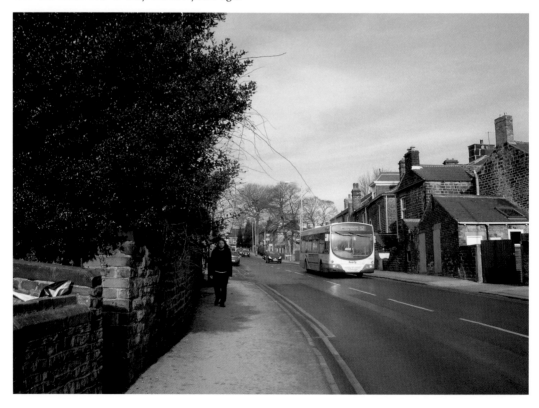

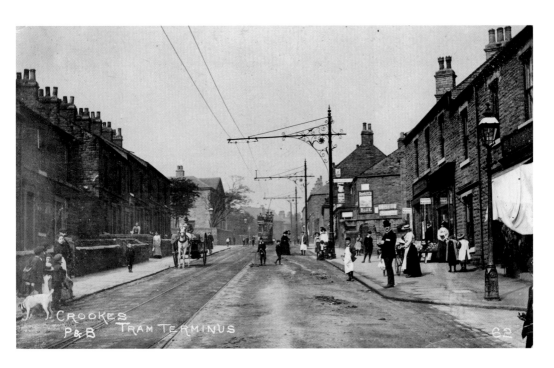

Crookes

The view, taken from the junction of Crookes and Coombe Road is from 1905. The ornate tramwire stands enhance the view.

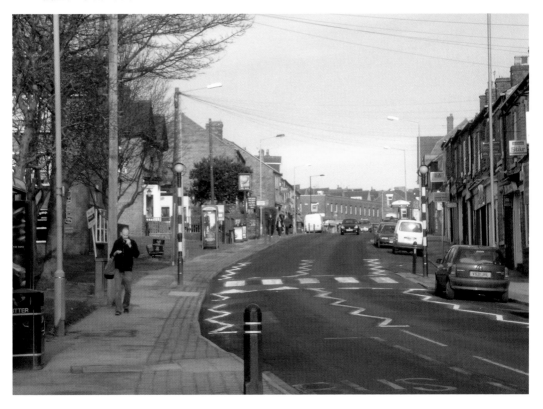

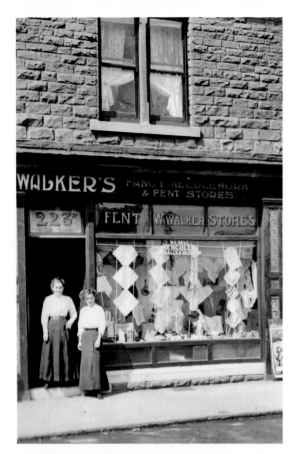

Walker's Shop, Crookes
This photograph, taken on 11 August 1914, is of Walker's drapers shop at 223A Crookes. The shop advertises fents (remnants) and Hercules overalls and blouses. It stood near the corner of Duncan Road.

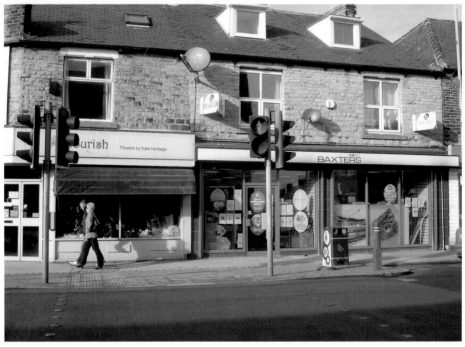

View to Stannington

The view across to Stannington taken shortly after the Second World War shows prefabs, built to house people who had lost their homes in bombing raids. The high-rise flats built in more recent years often housed people who were forced to move as a result of slum clearance and the redevelopment of the city.

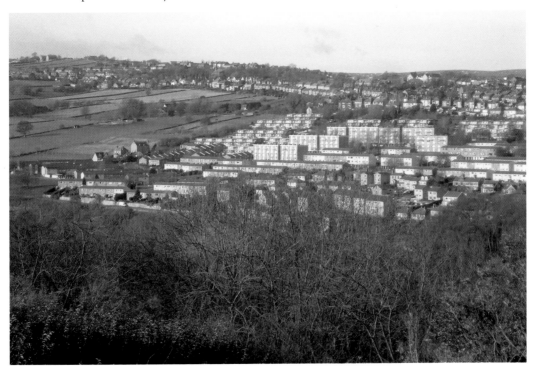

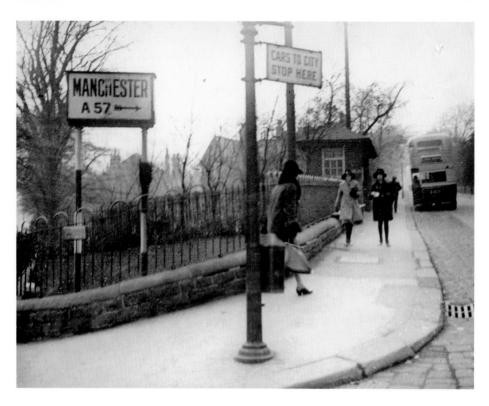

The Manchester Road Bus Stop

The photograph from 1930 shows a bus leaving Broomhill for Crosspool. The bus shelter remains and the corner plot has been made into a garden with seats. Street furniture makes a new view difficult to capture.

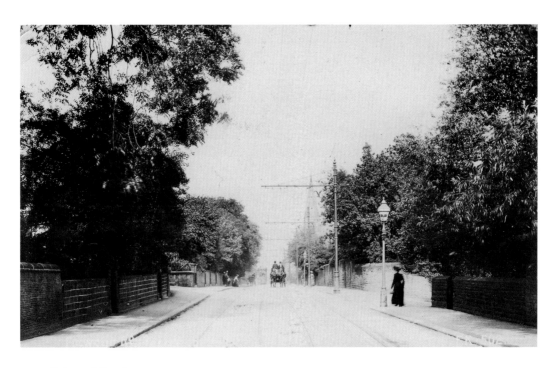

Fulwood Road

The view has changed little since the photograph of 1903. The Crookesmoor racecourse where horseracing took place between 1731 and 1781 followed the line of Fulwood Road in places. Broomhill Methodist Church was demolished and eventually rebuilt in 1998.

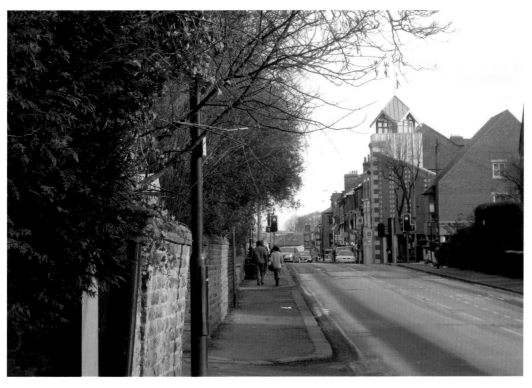

Acknowledgements

Once again, I am indebted to the kind people of Crosspool who have eased my way in the making of this book. Not only have I received photographs and information locally, but they have put me in touch with people all over the city and all over the country!

I apologise to any one I have omitted from the following list. Every effort has been made to discover the copyright of photographs but sometimes it has been impossible.

Thanks go to Sarah Billingham, Janet Bowring, Kay Burkinshaw, Bessie Cocker, Gordon Couldwell, Hilary Darlow, Rosalie Hoyland, Keith Kendall, Jane Laing, David and Lorna Lyon, Hazel Mann, Margaret Sanderson (Den Bank), Margaret Sanderson (Lodge Moor), Chris Stirling, Hannah Swiffen, Brenda Tew, Sylvia Walsh, Brian Watchorn, and Bill Hornby and Les Outwin from St Columba's Church.

I am grateful to Sheffield Local Studies Library for the use of some of their photos. I am especially grateful to Richard Cowen who, although living in Devon, heard about my book and offered me many never previously seen images of Crosspool.

No list of thanks would be complete without those to my patient husband, Hasse for his advice, and to my equally patient son, Anders, for his computing skills and having to deal with a technophobe!